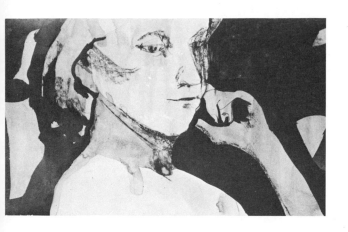

DRAWING MEDIA & TECHNIQUES

Charles Sheeler, *Interior, Bucks County Barn*, 1932.
Crayon on paper, 15" × 18¾". Whitney Museum of
American Art, New York.

DRAWING MEDIA & TECHNIQUES

Joseph A. Gatto

DAVIS PUBLICATIONS, INC.
Worcester, Massachusetts

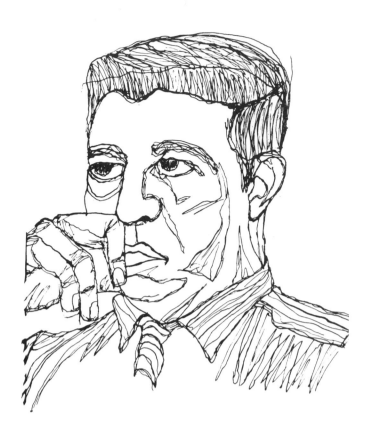

Barry Benaway, *Portrait*. Ink and stick, 11″ × 13″.
Courtesy of the artist.

Gustav Klimpt, *Woman in Profile,* ca. 1898–99.
Colored pencil, 16⅞″ × 11⅛″. The Museum of
Modern Art, New York, Joan and Lester Avnet
Collection.

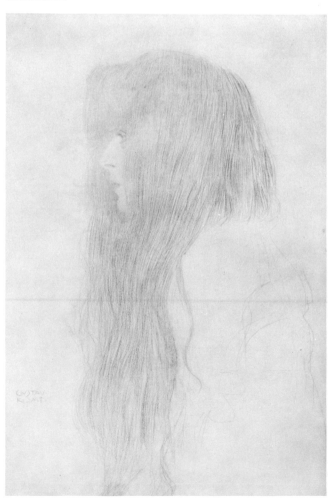

Copyright 1987
Davis Publications, Inc.
Worcester, Massachusetts U.S.A.

Design: Dede Cummings
Printed in the United States of America
Library of Congress Catalog Card Number: 86-72602
ISBN: 0-87192-187-1

10 9 8 7 6 5 4 3 2

CONTENTS

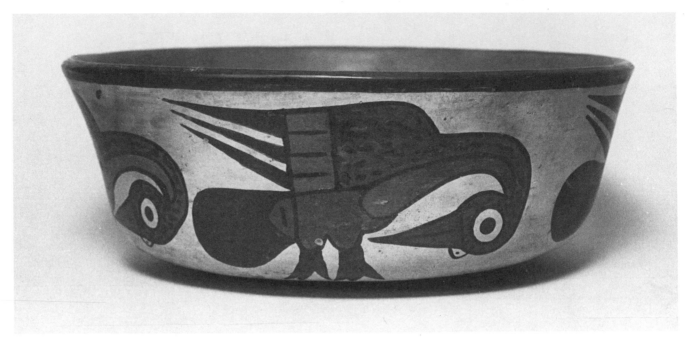

The Nazca Indians lived in South America thousands of years ago. They were skilled at ceramics and weaving. Their drawings relied on line, whether drawn or incised. Line created a passive quality in their work. As a drawing tool, the Nazcas used feathers or a thorn stylus. The Nazcas were fond of polychromed decoration in up to eight colors and would separate each value using line rather than mixing colors.
Nazca Bowl.

INTRODUCTION

Throughout history, artists have used many materials to express their responses to things seen or felt. A list of all the materials used to create art would be a long list. Artists have probably worked with most of the materials ever created by humanity.

Drawings and drawing media occupy an important place in the history of art. Like other media used by artists, some materials are easy to work with, some are long-lasting and some are complex, requiring greater understanding to use them well. You can learn to use materials of all kinds.

This book is about a variety of drawing media, used in diverse ways. The works of many different artists are shown here, representing hundreds of years of development in drawing. This book is designed to help develop your drawing skills, using beginning, intermediate and advanced drawing media. As you grow to understand the media, you will be better able to learn from the drawings in this book, and better able to create works of your own.

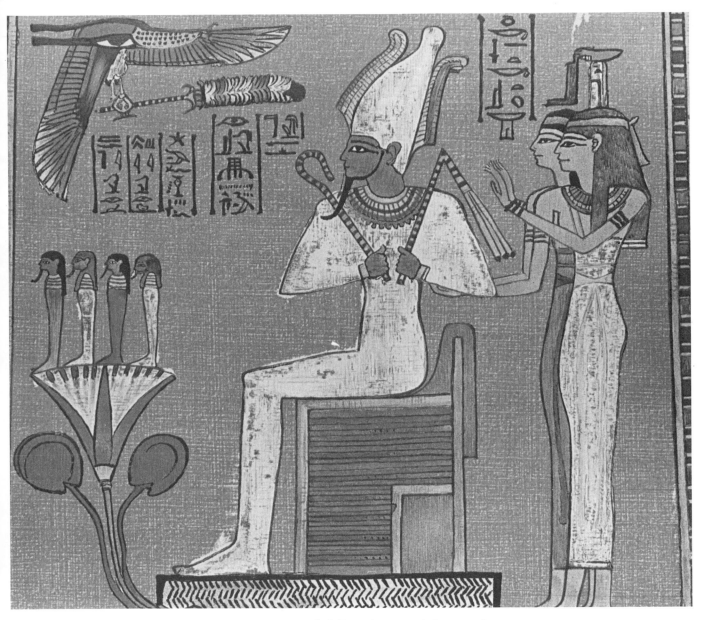

Much of art in all cultures relies on imagination and skill in drawing. It is one of the most essential methods by which people describe themselves and their environment. When papyrus paper was developed in Egypt, drawing took on a significant element of individuality. Before the development of paper, the artist as an individual was unknown. Instead artists were highly trained members of a team, with each individual assigned to a specific task such as a tomb maker or a sculptor.

Ancient Egyptian, Nineteenth Dynasty. Brush drawing in red and black with watercolor on papyrus. From a *Book of the Dead* from Thebes.

1
SETTING UP SHOP

How to Use this Book

This book invites you to experiment, to become familiar with many drawing media and create your own ways of using them. There are as many ways of using media as there are artists. No formal rules govern the use of drawing media.

As you work with different drawing materials, you will notice that certain media and techniques are best suited to certain needs. In some of the artwork shown here, the artists used more than one medium in various ways. You can do this, too, as you develop specific drawing goals. And as you achieve your goals, you join the ranks of artists who have long used drawing for personal expression.

To help you use materials effectively, dry, moist and wet media are introduced in that order. These represent beginning, intermediate and advanced materials. The dry media tend to be more familiar

and easier to control. The wet media are more difficult to use, and encourage more experimental, free-flowing work. Traditional and non-traditional drawing materials are organized into individual chapters with suggested sequences for using the media. The examples are arranged to parallel your growing knowledge and to develop your skills and confidence.

The conclusion of the book offers additional suggestions for using materials. These ideas are organized to correspond with the sequence of the chapters.

Beginning and Beyond

Basic drawing materials offer the means to create countless expressive drawings. The media can reflect unlimited inventiveness and imagination. Materials, implements and techniques can aid in the development of your own unique way of drawing, regardless of your skill level.

Drawing media provide a balance between freedom and control. They provide the opportunity to experiment continually with a variety of techniques. You can choose how to express yourself. You can develop drawing skills at your own speed.

As you learn to draw, you can learn broad new ways of thinking. Throughout history, artists have been receptive to new media, ideas, techniques and subject matter. Most artists are continually willing to develop and alter their style, as well. Artists seek new experiences beyond the basic media and the fundamentals of drawing. You can be a part of all this.

Avanced drawing media and techniques go beyond the basic drawing experiences. In this book, advanced information develops technical and stylistic skills that depend on a strong foundation in the basic drawing media. Your developing skills can yield great increases in satisfaction with your drawings.

New technology and innovative manufacturing have brought media to a level never imagined by ancient artists, who often made their own materials. Many of the media manufactured today have uniformly high quality and permanence, and can be used to produce numerous drawings. Basic drawing materials and implements can be assembled for little or no cost. All are lightweight and portable, and many can be found or recycled. Don't be daunted by the enormous quantity of choices in drawing materials. You can get started using a very modest collection of supplies, and add new ones as you broaden your skills and artistic goals.

A basic drawing kit can contain simply pencils and paper. As you progress you can add other media: charcoal, conte, crayons, markers, drawing inks, watercolors, a variety of drawing implements and brushes, along with media you already enjoy or discover while using this book. A piece of masonite will serve as a drawing board, and you can draw on most any paper or cardboard. You

Michelle Shih, *Portrait*. Red and brown conte. Courtesy of the artist.

can also make or purchase a sketchbook, so you can draw almost anywhere, at any time.

The papers used for drawing permit a wide range of exploration, and are vital to drawing. Try using rough and smooth, colored and white papers. Large and small, absorbent and non-absorbent surfaces should all be part of your drawing experience. Common newsprint, white butcher paper and brown wrapping paper can be used for everyday drawing exercises. The latter two come rolled, can be cut with a blade or scissors, and can be used with most dry, moist and wet media, and with mixed media. Newsprint is more suited for dry media and some moist media. Bond papers are better for wet and mixed media drawings. A variation of drawing papers can yield a rich variety in your skills and finished artwork.

Along with the obvious paper outlets, consider obtaining paper from other sources such as paper recycling firms. These will often sell end rolls of bond paper for considerably less than cut and packaged paper. Large paper bags offer a good surface for ink, wash and combined media drawings. You can draw on recycled gift wrapping paper and wallpaper found at outlet stores or garage sales.

Printing firms sometimes sell excess paper by the pound or by the end roll. The slick, clay-coated paper can be used with ball-point pen, markers, ink, wax crayons, oil pastels, grease pencils, acrylics, oils and some combined media. Some experimental drawings can be done on clay-coated paper as well. However, dry media and certain liquid media, especially those with weak binding agents, do not work well on slick drawing surfaces.

Newspapers can be recycled and are suitable for drawing when resurfaced using an inexpensive white latex paint or gesso. Prime the newsprint surface using a paint roller. When it is dry, store it flat, under a weighted board.

You can use large sheets of cardboard cut from shipping boxes. Department stores, markets and furniture stores often can provide this worthwhile drawing surface. Like newsprint, cardboard can be primed with latex paint or gesso. If a less contrasting surface is desired, the cardboard need not be primed, because the natural tan surface is compatible with compressed charcoal, conte, pen, brush and ink, as well as other media. The unprimed surface is also an excellent base for acrylic pigments and oils used in combination with some of the above media.

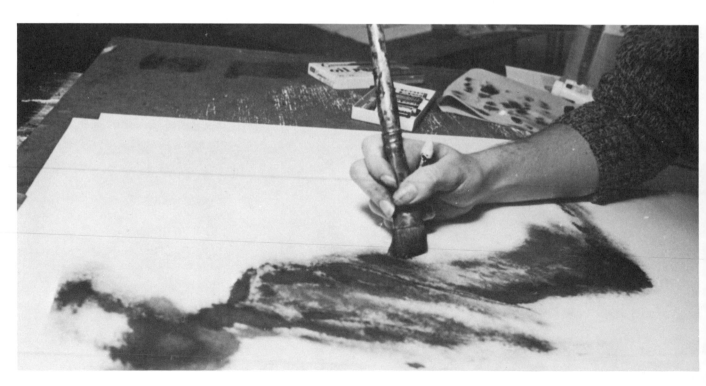

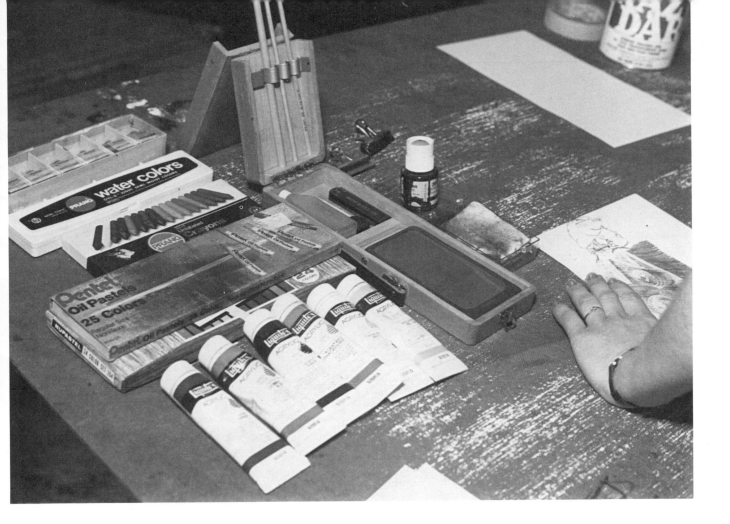

Suggested Media

The following media will be discussed in this book and eventually can be included in your drawing kit: one or two sticks of compressed charcoal; one stick of brown, black, sanguine and white conte; one stick of 4B graphite; liquid or powdered graphite; one box of large wax crayons; a grease pencil; drawing pencils of various hardnesses; a sketching pencil with rectangular lead (4B); ball-point pens with red, blue and black ink, a box of regular or oil pastels; markers with different tips and colors; a pen holder with one point inserted in the holder, and a contrasting pen point taped to the end of the handle (a dowel, stick, or discarded brush handle can be used instead of a pen holder); one watercolor set; a bottle of drawing ink; a small can of turpentine or paint thinner; one tube each of red, yellow, blue and white acrylic paint; one tube of an earth color, such as

sienna, ochre or umber; bristle brushes (½"-¾" wide); a #12 watercolor brush (sharpen the end of the handle with a diagonal cut to produce wide or delicate lines when used with ink); an inexpensive paint-trim or hardware brush, about two inches wide.

Your kit should contain drawing implements of all kinds: sticks; balsa; applicators; dessert sticks; thin dowels; twigs of different lengths and thicknesses; bamboo reeds (sharpened and used as reed pens); plastic coffee stirrers (sharpened with diagonal cuts); feathers; small squares of chipboard or cardboard; discarded 35mm transparency frames; small stiff plastic squares; clear paraffin wax; recycled dinner candles; small containers for mixing washes; and any other media you choose to include in your drawing kit. All of the materials and implements for some experimental media drawings will be discussed in a separate section of this book.

Drawing Environments

The natural and the human made environment surround us with visual riches. Wherever you can put drawing media to paper, you can find a drawing environment. This huge variety can be enormously inspiring.

At the same time, practical comforts can be helpful. Classrooms, workshops and studios often provide an orderly, clean, well-maintained work area. Adequate lighting, good ventilation and an even temperature allow you to focus on drawing. Try to avoid harsh glares that tire the eyes. Eliminate noises that interrupt your concentration on drawing.

For your indoor drawing environment, try to have really steady easels, tables or other furniture.

Plan floor space that will enable you to evaluate your work by stepping back to get a more distant view. Then you can easily check the relationships among form, value and proportion.

It's wise to keep your media in storage containers when you are not using them. This helps avoid spills and waste. You will value storage space for your drawings, too. Store drawings flat or rolled up, never folded or creased. Flat drawings can be kept in a portfolio made from two large sheets of cardboard hinged with tape at the bottom.

The drawings that you decide to keep should be sprayed with a protective fixative, especially dry media drawings. **When using fixatives, be sure to follow the manufacturer's suggested safety precautions. Generally you'll need a well-ventilated area, away from your usual working space.**

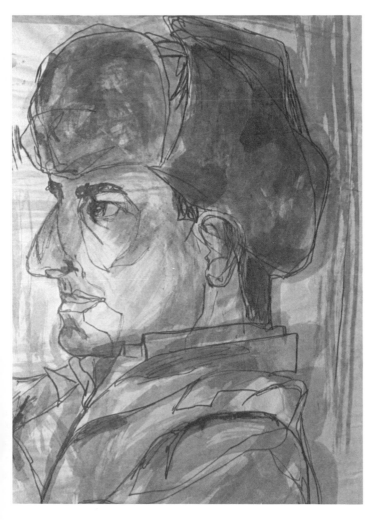

Scott Michael, *Portrait*. Wash, ink and line on brown paper. Courtesy of the artist.

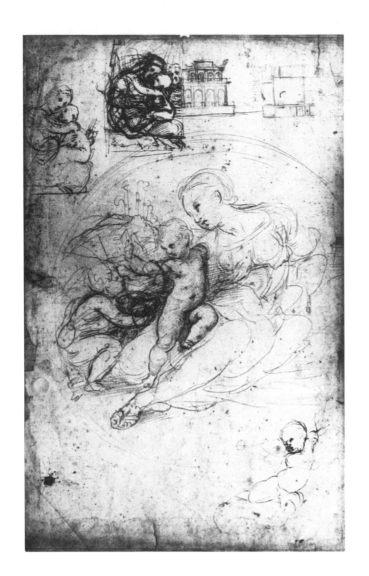

A drawing can be compared to any body of knowledge requiring research and investigation. It is how artists learn about the visual elements, media, drawing surfaces and subject matter. For this drawing Raphael Sanzio explored the media of chalk and pen and ink. He used them to produce value and line until areas of the drawing gained greater significance. Some drawing media allow artists to alter ideas repeatedly, make judgments and comparisons, and work on drawings until they feel right.

Raphael Sanzio, *Study for the Alba Madonna*. Pen and red chalk, 13¾″ × 10½″. Musées d'Art et d'Histoire, Lille, France.

2

SOME BASICS OF DRAWING

Drawing, Illustration and Cartooning

Most of us easily recognize cartoons. We are not apt to confuse them with drawings or illustrations. The difference between drawings and illustrations is not always clearly defined, however.

You can't count on the materials to show you the difference. Many of the media you draw with are used by cartoonists, illustrators and fine artists.

At one time or another during their careers, artists such as Pablo Picasso, Ben Shahn, Georges Rouault, Paul Klee and George Grosz have used the same media to create all three art forms: cartoons, illustrations and drawings.

Cartoons are humorous or satirical drawings. They range from realistic illustrations to abstract designs. The techniques and media used by cartoonists vary as much as the mood, wit and

humor of their drawings. Cartoonists aim to amuse us or express an opinion.

Illustrations are made to be reproduced. They are created by artists whose goal is to make images that are understood by a large number of people. To do this, illustrators always carefully control their media, drawing surfaces, and the objects being drawn.

Drawings, on the other hand, are created by artists whose goal is to show, on paper, their artistic responses to the world. These artists explore the ways in which media, surfaces and subject matter interact. They are free to work with media in any manner or style, and often take advantage of inadvertent results that occur while drawing. In a drawing, accurate representation is not necessarily a primary goal; abstracting often enhances the expressive qualities of the work.

This book is geared toward drawing, as the title implies. You may very well improve your cartooning or develop fine skills as an illustrator while you learn to use various drawing media. It is hoped that you will learn artistic freedom and expressiveness, as well, and create your own fine, original drawings.

The illustrator uses drawing media to clarify and amplify ideas about objects. Media are not used for personal expression or for special effects. Instead the media are controlled so that they are not misleading, unclear or confusing.
Chris Polentz. Acrylic and prisma color, 15″ × 20″. Courtesy of the artist.

"WELL, AT LEAST IT'LL BE CHEAPER THAN IF HE'D HIRED A MAN..."

The artist who drew this cartoon used pen, brush and ink. Other media can be used for cartoons, too. Editorial cartoonists often rely on day-to-day news events to suggest subject matter. Cartoons are characterized by distortion, humor, satire and wit. Courtesy Jim Borgman, *Cincinnati Enquirer.*

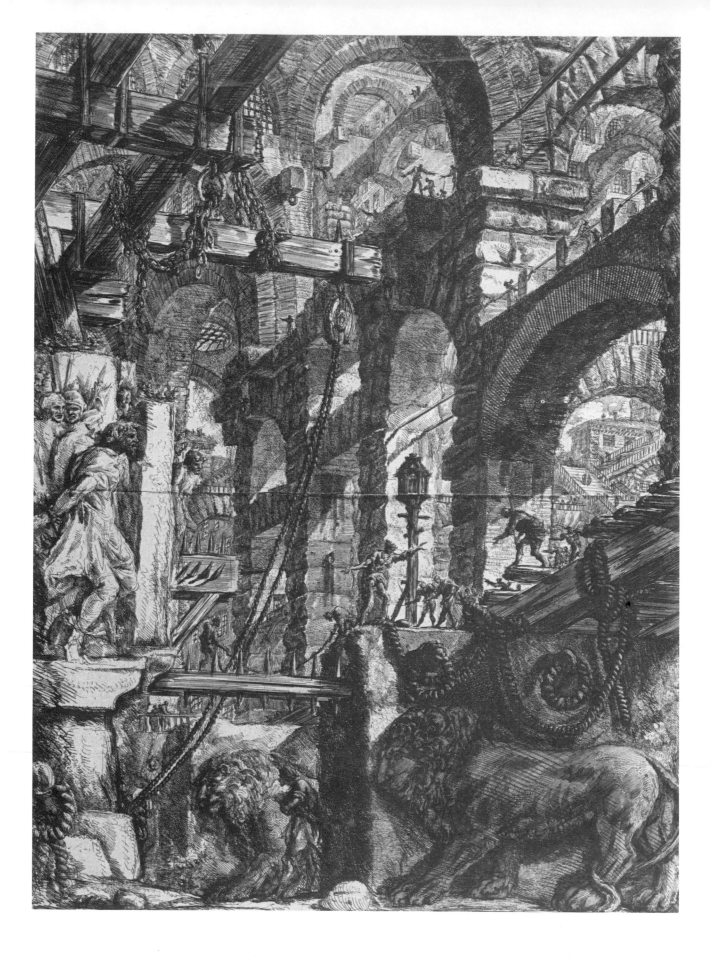

Illusion Making

The surface of drawing paper is two dimensional. It has only height and width; it is flat. The world we live in has depth as well; it is three dimensional. In drawing, artists create illusions of three dimensional space on a flat surface. A drawing can be an illusion of what you see. Some of your more interesting drawings will appear to have a dimension of depth.

There are many ways to draw something so that it looks three dimensional. Some illusion-making techniques are explained here. These will help you learn to create drawings that represent dimensions, form and space.

Value: As you look about, your eyes automatically inform your brain that certain objects are near you or far away. One of the clues to distance is the lightness or darkness of each object. An object's lightness or darkness is its value. Value is also referred to as tone.

Light objects generally appear nearer than dark ones. Light areas of a surface appear nearer than dark areas. You can draw a gradual change in value to imply receding distance, curved forms and much more. Value helps convey moods, ideas and emotions as well as distance and form. Value can provide impact in drawings. It helps define space, the surface appearance of objects and the three-dimensional aspects of form.

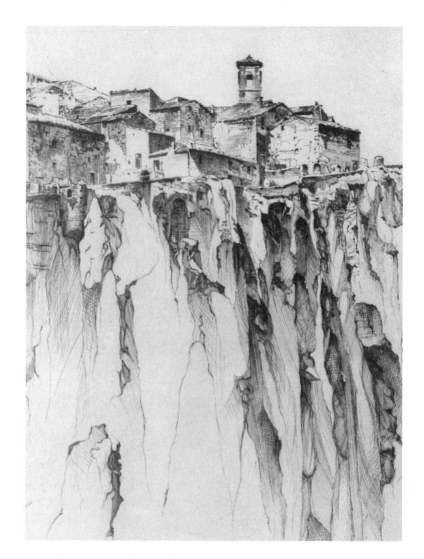

American artist John Taylor Arms drew the buildings of the small Italian town high up on the picture plane. The buildings contrast with the cliffs that have been drawn lower and slightly larger. The combination of location and rotation of line enhances the illusion of space and dimension.
John Taylor Arms, *Grim Orvieto*, 1926. Etching, 11" × 9¾". Los Angeles County Museum of Art, purchase from Printmakers' Society.

Giovanni Piranesi made a series of etchings where the images of the imaginary prison interior appear monumental in scale. To achieve this the artist used size variation. The larger objects were drawn lower on the picture plane and contrast with the smaller forms that were drawn higher in the composition. The lions and figures to the left were drawn as large as the architectural elements and gradually diminish in size until they are barely perceptible. The illusion is one of deep space.
Giovanni Batista Piranesi, *A Perspective of Roman Arches, With Two Lions in The Foreground*. From *(Imaginary Prisons)* plate V, etching, 24" × 30". Los Angeles County Museum of Art Gift of the William Randolph Hearst Foundation.

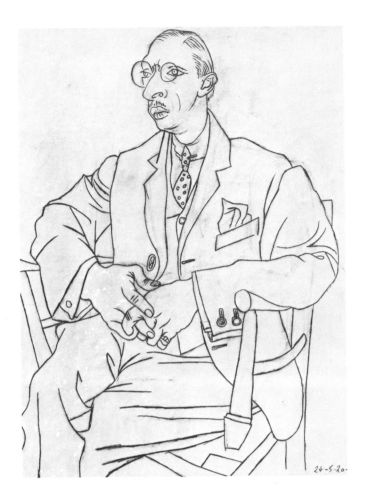

Pablo Picasso made this drawing of the composer Igor Stravinsky in 1920. Line is the principle visual element. Very few of the lines have been drawn parallel to each other or to the edges of the picture plane. Put your finger on one of the lines of the drawing. Notice how the line encloses an area on the drawing surface, creating a small shape as well as contributing to an illusion of dimension without using value.
Pablo Picasso, *Igor Stravinsky*, 1920. Pencil on gray paper, 24⅜″ × 19⅛″. Musée Picasso, Paris.

other lines. When lines are drawn parallel to the paper's edge, the objects in the drawing appear flat, as if they have height and width, but no depth. To make your drawings appear three dimensional, practice drawing lines that are not parallel to each other nor to the edges of the drawing surface.

Size: You have probably discovered that an object can be made to appear near or distant by altering the object's size. Large forms appear to be close to us, and smaller forms appear to be farther away. You can use size to represent three dimensions in artwork.

Location: You can indicate depth by drawing distant forms toward the top of the drawing surface. Draw near objects lower on the picture plane. You can make the decisions about location, or placement. Look through this book and find those drawings in which artists have used placement to achieve illusions of deep and shallow space on the picture plane.

To make your drawings appear three dimensional, you can learn to use media that produce light and dark values. You control the values in your drawing by varying your hand's pressure on the drawing medium. You decide how much of the medium will accumulate on the drawing surface. Some of the more common value-producing media include charcoal, chalk, conte, crayons and graphite.

Rotation of Line: As you look through this book you will see that some artists did not use any value in their drawings and yet they achieved images that appear to have depth. You can make drawings that look three dimensional by using only line.

Look carefully at those drawings where only lines have been used. You will see that the artists did not draw any lines parallel to the edges of the drawing surface, nor were lines drawn parallel to

American artist Charles Sheeler made this combined media drawing, creating an illusion of shallow space, dimension and form. Several examples of overlapping can be seen. Dimension and depth were achieved by overlapping forms. Parts of forms were drawn in front of others. In this drawing, notice that the telephone overlaps the window sill, the pane of glass, and the cord from the shade. The reflection of the artist can be seen in the glass. The reflections are used as overlapping elements and are necessary to the composition.
Charles Sheeler, *Self-Portrait*, 1923. Conte, gouache and pencil, 19¾″ × 25¾″. The Museum of Modern Art, New York, gift of Abby Aldrich Rockefeller.

Color: Warm colors appear to advance toward you. Cool colors appear to be more distant. Consider, for example, how you might represent distant hills. The near hills are green. The succeeding ranks of hills are bluer and bluer. Color in drawings can work well to represent space.

Overlapping: Your environment is made up of forms and shapes that appear to be in front of or behind one another. The nearer form blocks a full view of the more distant form. This is overlapping. It is impossible to go through the day without seeing examples of overlapping.

In drawing, you can use overlapping as an illusion-making technique to show depth. Try overlapping the visual elements (shape, value, line, color and texture). When you overlap two values, two shapes, and so on, you will suggest an illusion of depth in your work.

Contrast the elements well, to avoid having them appear to merge. When you overlap two colors, for example, be sure they will not simply blend when you stand back from your work.

Overlapping is often used in drawings. In many drawings it is not possible or desirable to use other illusion techniques. You will find that various techniques may not be suited for specific types of drawings.

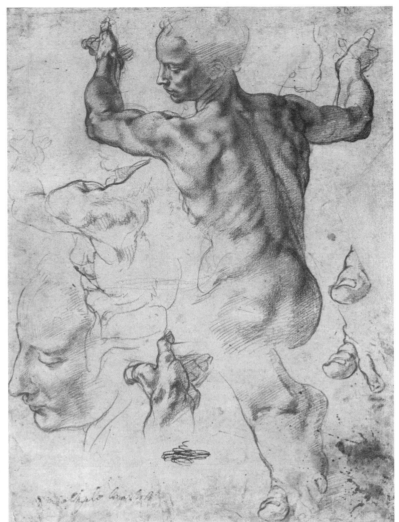

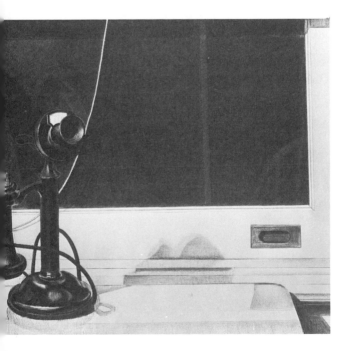

Michelangelo explored the human form, the drawing surface, and the medium of chalk, in this drawing. The values of the chalk make the upper torso appear three-dimensional, and more believable, while making the form appear to go back in space. Darks were placed next to lights created by allowing the drawing surface to show through the colored chalk. Michelangelo was one of the first artists to use the value of the drawing surface as an aid in describing form.
Michelangelo Buonarroti, *Studies for the Libyan Sibyl.* Red chalk, 11⅜" × 8⅜". The Metropolitan Museum of Art, New York, Joseph Pulitzer Bequest.

15

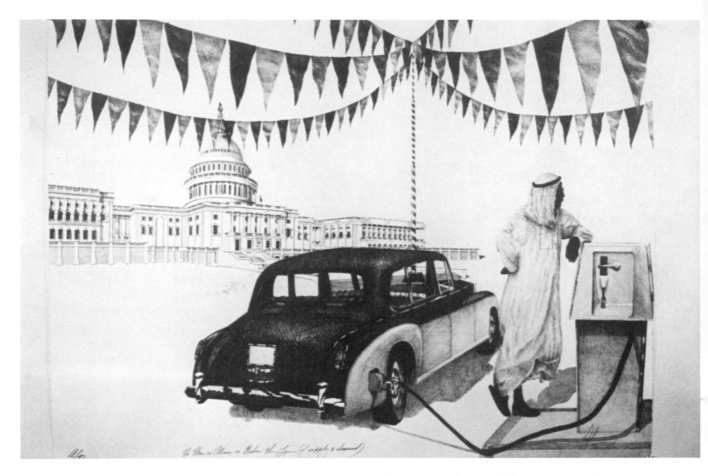

The drawing for this lithograph was drawn in two stages. The pen and ink drawing was drawn in two-point perspective aided by angles and straight edges to help the artist determine the correct placement of the building on the picture plane. The automobile and figure were done separately and added at later time. They were also drawn in perspective.
Gregory Dickson, 1984, *Petro Bucks*. Lithograph. Courtesy of the artist.

Perspective: This is a scientific illusion-making technique developed by artists several centuries ago. They devised it to determine the correct placement of forms on a picture plane. Perspective can determine the degree to which forms appear three dimensional.

The process of taking photographs is familiar to many of us. Photographs are mechanically produced perspective images and are not unlike the images drawn in perspective by artists. Photographic images are two-dimensional representations of three-dimensional forms. Photographs are produced on a picture plane and approximate the way we see nature.

There are two kinds of perspective views in general use. The most common is two-point perspective. This has two vanishing points, one to the left and one to the right of the picture plane. The other type of perspective used by artists is that having only one vanishing point. There are other systems of perspective that belong to one- or two-point perspective. They include: bird's-eye view, suggesting that the object is viewed from a position high above it, and worm's-eye view, as if seen from a point close to the ground. In addition, there is three-point perspective, used to describe forms such as tall buildings or other tall objects in bird's-eye or worm's-eye views.

Keep all of these illusion-making techniques in mind as you experiment with the media explained in this book. Enhance your drawing skills with your own inventiveness and imagination, and create your own images of the world!

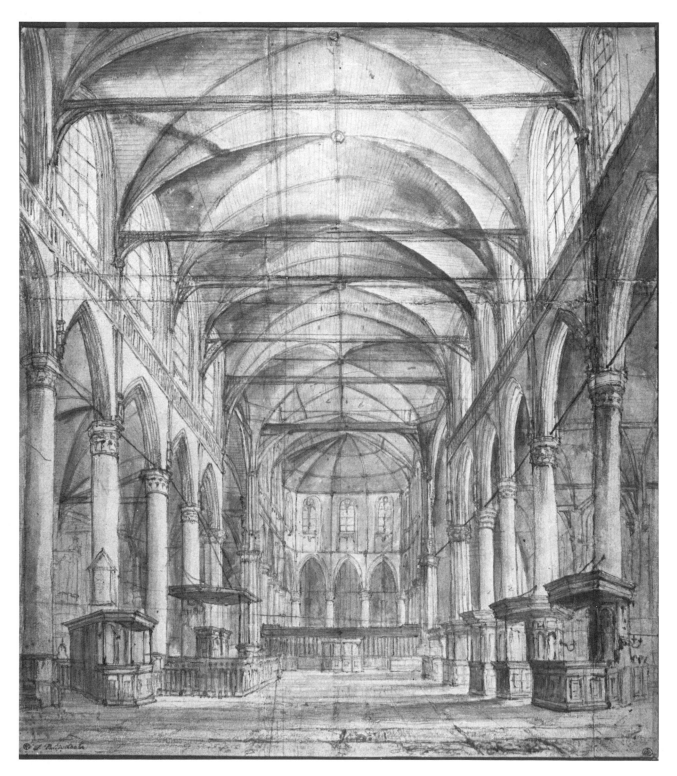

This drawing is an example of one-point perspective. Just as in two-point perspective, the vanishing point is placed on the horizon line. The horizon line is also known as the eye level. In this drawing, all the diagonal lines of the church interior appear to converge at the small black dot located in the center of the altar. The beam indicates the eye level of the drawing. Above this area, the vast amount of space gives the drawing monumental scale.

Jacob van Ruisdael, *Interior of the Old Church, Amsterdam*, ca. 1650. Chalk and wash, 19″ × 16⅝″. Ecole des Beaux-Arts, Paris.

3

CHARCOAL

Charcoal is one of the oldest, most widely used and popular of drawing media. There are two types of charcoal: stick and compressed. Stick charcoal is burnt wood or vines that have been reduced to carbon. The sticks are soft and brittle and should be used with charcoal paper. Compressed charcoal is made by burning selected woods in chambers, or kilns, where flames are deprived of oxygen. This prevents burning the wood completely. The brittle carbon is ground into powder and compressed under pressure into chalk-like sticks, of various shapes and hardnesses. Water, turpentine and paint thinner can be used as solvents. Charcoal can be combined *with a variety of other drawing media,* with paints of many kinds and with gesso. Collage artwork can include charcoal, too.

Charcoal makes dark values when you push it down firmly, and lighter values when you lessen the pressure. Values help describe form and depth. By increasing the contrast between tones, the illusion of depth is enhanced.
Valerie Katzko, *Vasquez Rocks.* Charcoal and traces of conte, 10″ × 13½″.

Before you begin drawing with any new medium, try to become familiar with what it can do. On practice sheets of paper, make as many values, lines, textures and shapes as you can. Look through this book for media that interest you and see how many ways media can be used. Try many of the combinations on your practice sheets and in your drawings. You will probably invent some uses of your own.

Break a piece of compressed charcoal in half. On scrap paper, use the flat side to cover an area about three inches square. Press hard and create loose charcoal dust. Next dip your thumb, index finger and palm in the dust. Draw a spherical form with your thumb, index finger or both. Repeatedly apply dust to the paper. Try drawing the sphere so that it reflects an imaginary light source. Where will the light areas be? Use your thumb and index finger for smaller forms and your palm for larger objects. Use a charcoal stick to complete the preliminary drawings.

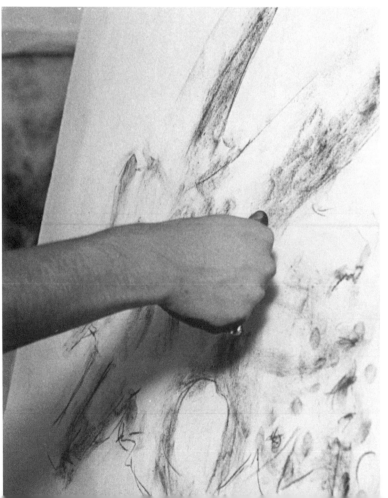

Preliminary drawings can be started with dust-covered thumbs, index fingers or palms. Concentrate on the values that make up the form, rather than outlining the object and filling the values as you go. After a few minutes, the form will seem to emerge from the surface, created by the values made with your thumb and finger. You can begin drawing with your charcoal stick to create darker values and any lines needed to describe the form. Try to draw from light to dark. Keep in mind that the purpose of this initial technique is to explore the interaction of medium, surface and subject matter. Try to distinguish the difference beween drawing and coloring.

Hold a piece of charcoal between your thumb, index finger and middle finger. Use the flat side of the charcoal to produce values, shapes and textures. Use the edges and tips to make different lines. As you experiment, become aware of changes in pressure and changes in the position of your hand as you make the different marks on the paper. Try holding the charcoal differently to produce marks that are more inventive and personal.

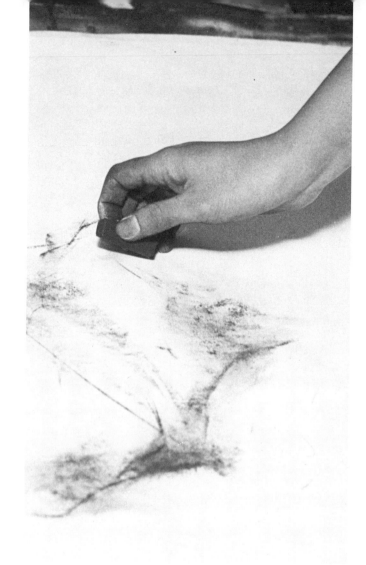

Charcoal, chalk, conte, graphite and crayons will produce different tones or values as you use different drawing surfaces and pressures. You can vary the quantity of the medium that sticks to the drawing surface. Practice changing the amount of the drawing surface that shows through the medium. The size, color and texture of the drawing surface will also change the appearance of values.

German artist Kathe Kollwitz made this self-portrait
using charcoal. Flat, broad strokes, rapidly drawn,
describe the upper torso and arm of the artist. The
strokes contrast with the subtle, sensitive values of the
face and hand.
Kathe Kollwitz, *Self-Portrait*, 1935. Charcoal,
16″ × 17″. National Gallery of Art, Washington, D.C.,
Rosenwald Collection.

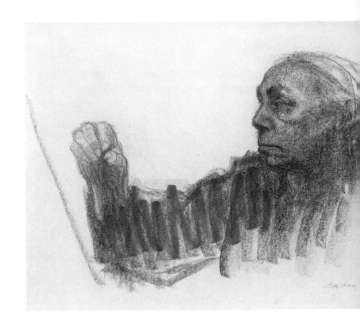

Charcoal has the potential for producing a wide range of values and lines, as in
this drawing of a skull fragment. Try making a series of drawings of symmetrical
forms (identical on both sides), and a series of drawings of asymmetrical forms,
such as crumpled paper, partially opened lunch bags, wrinkled foil, the inside of
a purse with its contents, a section of an automobile engine, or animal skulls.
Compare both types of drawings, and the problems you may have encountered
with value and line.
Toni Brownell, *Skull Fragment*. Charcoal, 18″ × 24″.

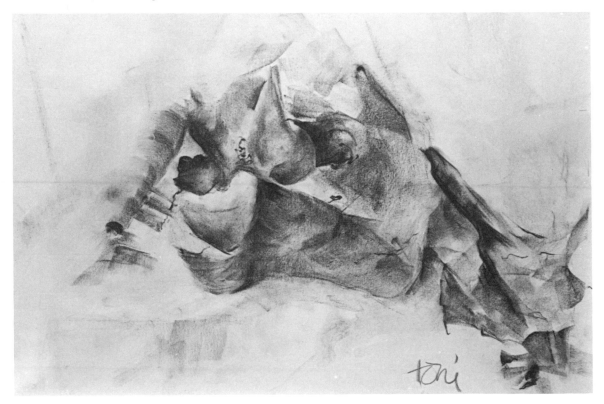

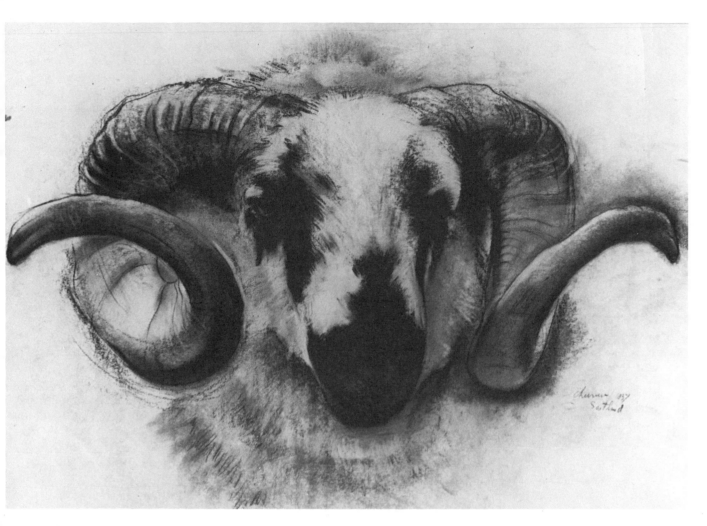

The soft qualities of charcoal allow artists to smudge and rub it to produce values. With charcoal you can draw faintly to produce contrasting lines. William Cheever used a crisp line to edge the form, and to separate similar values in the background from those in the foreground, in this drawing. The white of the paper was allowed to show through the smudged charcoal on the animal's head and horns, creating an illusion of roundness. Look at this drawing with your eyes half closed, and study the way the light values appear to advance.

William Abbot Cheever, *Ram's Head,* 1937. Charcoal, 14″ × 20¾″. Addison Gallery of American Art, Andover, Massachusetts.

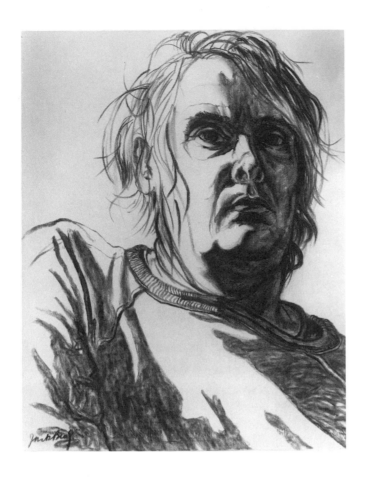

This self-portrait was done by American artist Jack Beal using charcoal on textured paper. The artist preserved the white of the drawing surface and created interesting shapes on the picture plane. Look at the large white shapes of the face, chest, left arm and background. The shapes were created by charcoal surrounding areas of the white paper. Many drawings are made without covering the entire drawing surface.
Jack Beal, *Self-Portrait (worked up)*, 1972.
25½″ × 19⅝″. Charcoal, 1972. Courtesy Allan Frumkin Gallery.

Charcoal shares with other dry drawing media many unique qualities. Charcoal can be rubbed, erased, reworked and combined with other media. Charcoal's flexibility allows you to change your drawing as often as necessary or until the drawing feels right to you. This drawing by French artist Honoré Daumier is an example of the artist's exploration in charcoal and ink. Does the drawing challenge your imagination? What techniques can you identify?
Honoré Daumier, *Un Avocat Plaidant*, ca. 1843–46. Charcoal and pen and India ink, 6¼″ × 8½″. Armand Hammer Foundation, The Armand Hammer Daumier Collection, Los Angeles, California.

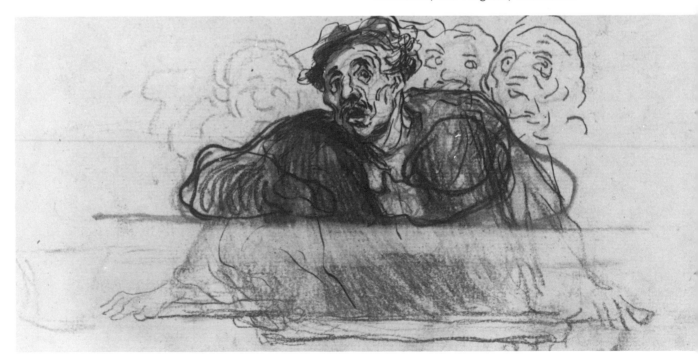

When you half close your eyes and look at this drawing by Kathe Kollwitz, two large shapes dominate the picture plane. They were made with ink washes. Charcoal can also be liquefied and used as a wash by diluting it with water or turpentine. **Always follow safety precautions when using turpentine.** A charcoal wash is applied with a brush. Try drawing with a charcoal stick into wet areas of water or turpentine, or draw into dry areas with washes made from charcoal.

Kathe Kollwitz, *The Homeless*, 1909. Charcoal and wash, 13¾″ × 12½″. National Gallery of Art, Washington, D.C., Rosenwald Collection.

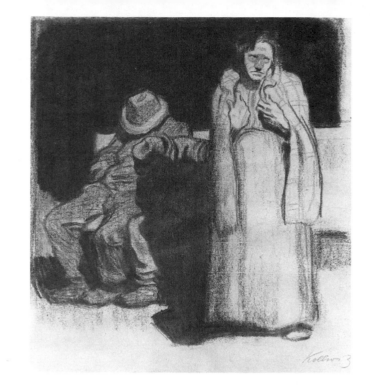

American artist William Hunt made this drawing of his observations of a baseball game. He did not feel obliged to record it in meticulous detail. The two figures in the foreground were drawn with similar values. In order to make one form appear closer, the artist drew it larger. When you look carefully, an example of perspective can be seen connecting the heads and feet of the players.

William Morris Hunt, *Baseball*. Charcoal, 14¼″ × 20¼″. The Museum of Fine Arts, Boston, Massachusetts.

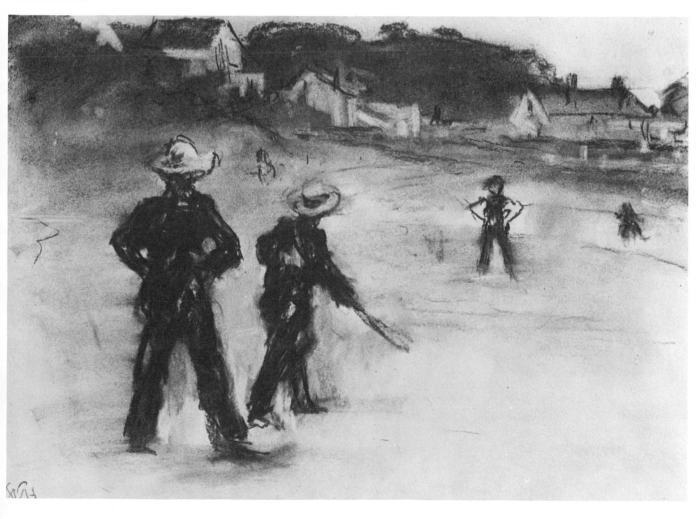

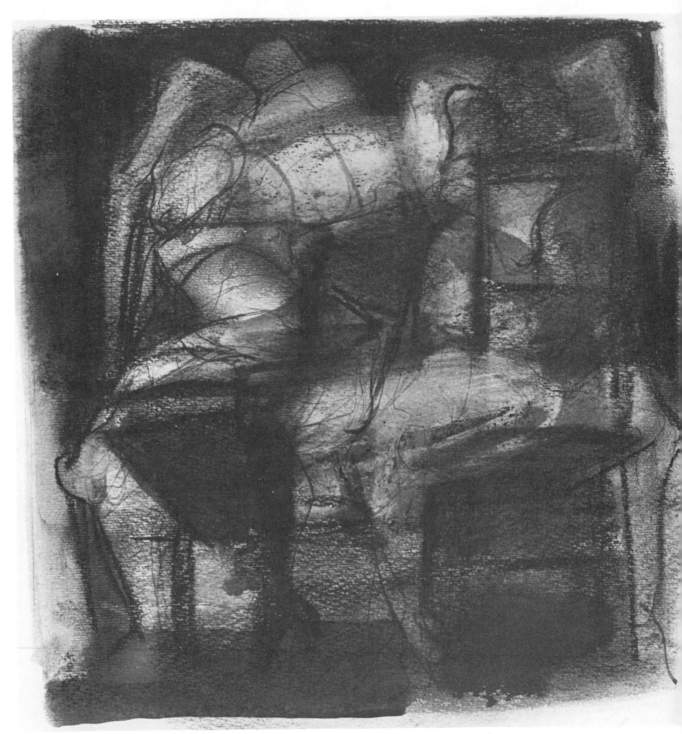

American artist Rico Lebrun used charcoal and ink on this drawing of two seated figures. The artist diluted charcoal dust with water to create a wash. He used a watercolor brush to apply the wash to selected areas of the drawing. Try using charcoal over water, watercolor or turpentine, and observe what happens to lines and values. On the same surface, reverse the process by drawing first with a charcoal stick, and then brushing liquid media over it with a brush, rag or moist paper towel.

Rico Lebrun, *Seated Figures*, 1962. Charcoal, wash, ink, 9½″ × 10″.

Paul Klee made this drawing using charcoal and water-color washes. Liquid media over charcoal reduced the contrast between the drawing surface and the drawing medium. On a practice sheet of paper, use charcoal to create some values, lines, shapes and textures. Apply watercolors, ink washes, water or turpentine with brushes over the charcoal. Observe the results of wet over dry and then reverse the process. Look at this drawing once again. Were the lines of the hair, ear and collar drawn over a wet or dry surface?
Paul Klee, *Portrait,* 1907. Charcoal, watercolor washes, 9½″ × 13″. The Brooklyn Museum, New York.

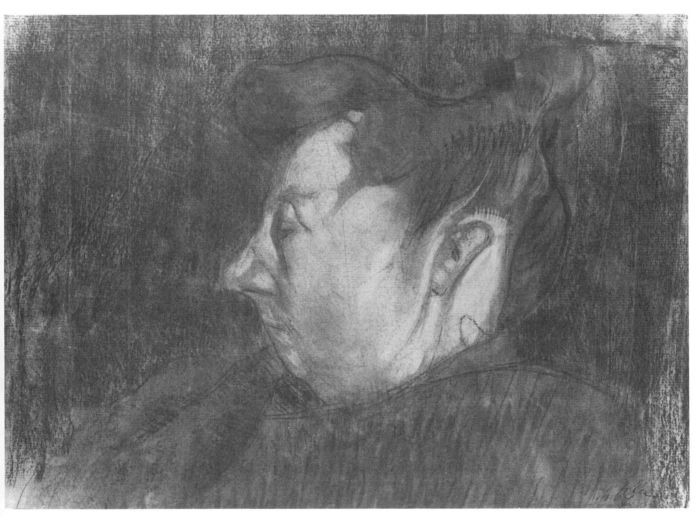

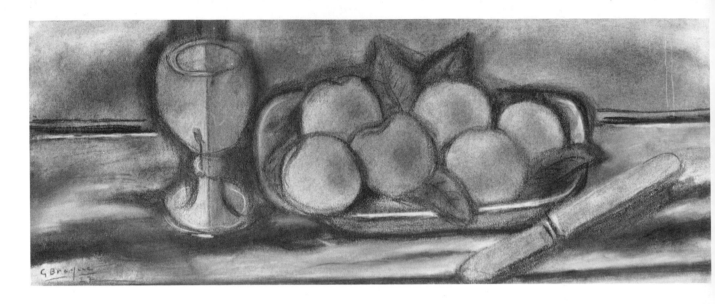

4

CHALK AND PASTEL

Chalk

Chalk, like charcoal, is an ancient drawing medium that became widely used in 15th-century Italy. Leonardo da Vinci used red and black chalk for many of his drawings. Originally, chalks were cut from natural chalk stone. They generally satisfied artists' requirements for consistent color and texture.

Natural chalks are no longer available. Instead, fabricated chalks are more common. Artists also use pastels made from pastes mixed with dry pigments and various binding agents. Two or more different pigments may be mixed with various binders to produce innumerable tints, tones and shades. Manufactured chalk comes in varying degrees of hardness. Chalks are manufactured in stick and pencil form, from coarse to fine, soft to crumbly and dry to greasy. Charcoal, pastel and conte can be referred to as chalks and to some extent can be erased, depending on the binding agent used. Chalks that have a waxy base are less erasable.

Chalks must be used only on a surface that has enough texture to wear down the chalk. The abrasive action deposits chalk dust particles on the drawing surface and rubs particles into the surface. The softer chalks provide painterly qualities. Excessive rubbing and blending of values reduces their contrast. This is a technique generally not favored by advanced artists. Contrast is essential, especially if you combine chalk with other drawing media.

Chalk drawings can be fragile, especially those created with chalk that has weak binding agents. Modern spray fixatives can help to preserve your artwork and can allow you to redraw selected areas of your work. **Use fixatives only according to the manufacturer's suggested safety precautions, in a well-ventilated area away from your usual working space.** Chalk drawings can also be preserved by placing a piece of wax paper over the drawing surface and pressing with a warm iron.

Georges Braque, along with Picasso, was a co-founder of an art form known as Cubism. It is typified by flat geometric shapes. Braque did not use traditional modeling on this drawing. He chose instead to reduce the contrast between values and to preserve the flatness of the picture plane. After studying the work of the Cubists, make two drawings of still-life forms using pastels. On one drawing, use the medium with considerable rubbing, and on the other, eliminate rubbing entirely. Try limiting yourself to only one color and create many tints, tones and shades of that color.
Georges Braque, *Still Life with Glass, Fruit, Dish and Knife.* **Pastel. The Art Institute of Chicago, Potter Palmer Collection.**

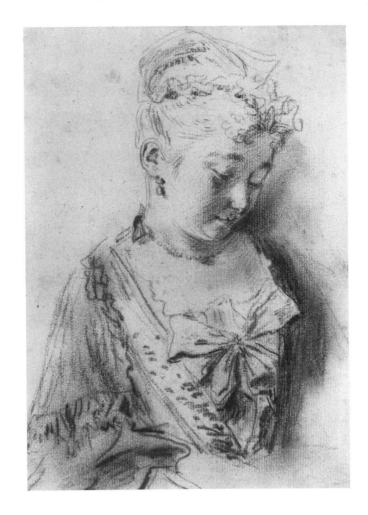

French artist Antoine Watteau drew the face in this drawing with red chalk, using traces of black on the eyebrows. The red chalk discloses the paper's texture. Notice that the chalk was rubbed to create the left sleeve, neck and face. The darker hue of the lips, bow, and jewelry were made with moistened red chalk. Black chalk on the right side of the drawing separates the figure from the background, suggesting shallow space.
Antoine Watteau, *Young Girl,* **ca. 1720. Red and black chalk, 8½″ × 5¾″. The Armand Hammer Foundation, Los Angeles, California.**

A drawing can be started with a chamois, rag, or piece of felt that has been saturated with chalk dust. An interesting drawing implement can be made from a discarded transparency frame as well. You can dip the edges into dust from chalk, charcoal or conte and begin your initial exploration without getting too dark. A transparency frame can be used with wet media as well. Look at the chapter on ball-point pen drawings, especially the work of Giacometti. The scribble technique can be used with light-colored chalk on large sheets of paper to begin a drawing. Contrast this technique with darker chalk or charcoal and controlled drawing gestures.

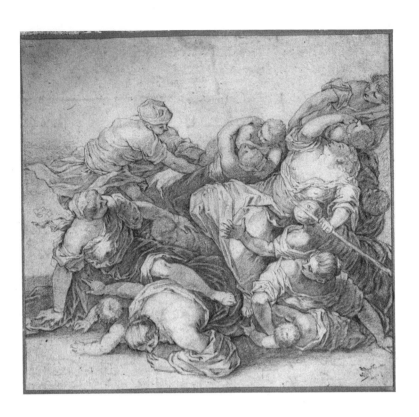

Italian artist Jacopo Rubusti made this drawing using red chalk. Even though it is quite small, it appears to be monumental in scale. The paper has a gray surface that prompted the artist to use a lighter medium for the highlights on the figures and fabric folds. Rubbed chalk permits the subtle rendering of skin tones and fabric. Try making a series of chalk drawings using an article of clothing, drapery or other fabric as subject matter. Jacopo Robusti (Tintoretto), *The Massacre of the Innocents*. Red chalk, 6¹¹⁄₁₆″ × 6¹⁵⁄₁₆″. National Gallery of Canada.

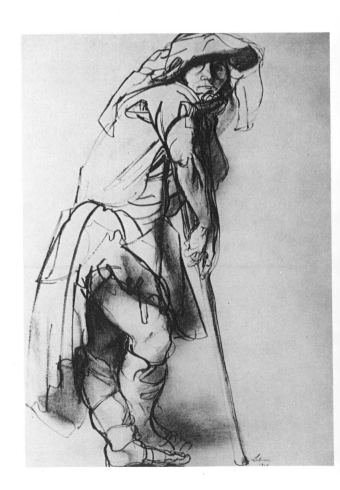

Many artists use colored papers for their drawings. Gray papers are often used for the wide range of values they can enhance. Where a form is darker than the paper, darker media are used. For forms with lighter values, a medium lighter than the paper is used, less hand pressure is applied, or the color of the paper is not disturbed. Rico Lebrun used gray values to help describe fabric, flesh and space.
Rico Lebrun, *Woman Leaning on a Staff*, 1941. Ink and chalk, 25¼″ × 11¼″. Collection of Mr. & Mrs. Thomas A. Freiberg.

Pastel

Artists have drawn with pastels for thousands of years. Pastels offer control and quick results. Often they satisfy the artist who chooses to make drawings in color. Pastels, like chalk and charcoal, can be used alone or in combination with other drawing media, especially water-based paints.

Prehistoric artists may have created pastels by grinding colored earth between two stones, mixing the pigments to a dough-like paste with water and a binder (perhaps the juice of certain plants). They may have then pressed the mixture into hollow animal bones. The bones could be put in warm ashes or out in the sun to dry at which point the finished pastel would fall out.

Modern pastels are made with finely ground pigments mixed with gum tragacanth and shaped in wooden or metal molds. Pastels are fine quality chalk with consistent texture and intense colors. They are available in a wide range of colors and degrees of hardness.

The softer pastels require a drawing surface with sufficient texture to hold the pastel particles. Harder pastels are more permanent and are more difficult to rub or erase. Softer pastels can be rubbed and spread with fingers or thumbs so that no traces of the stroke remain. Only a few particles of the medium penetrate into the pores of the paper from the rubbing. The smaller the particles, the deeper they penetrate and the harder it is to smudge them or rub them out. As a result, excessive rubbing reduces the contrast of the medium and destroys the fresh appearance of the drawing.

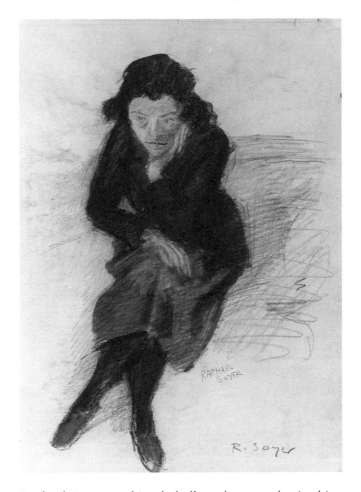

Raphael Soyer combined chalk and watercolor in this drawing, using the softer chalk to produce the rich dark blacks. The artist did not blend the chalk by rubbing. He chose instead to build up layers of value with repeated applications and by altering his pressure on the chalk. Watercolor was used to produce the colored washes. When combined with chalk, watercolor reduced the contrast on that part of the drawing, establishing shallow space. Scribbled chalk and cross-hatching describe the background and parts of the form.

Raphael Soyer, *Young Woman on a Cot*, 1930. Chalk and watercolor. I.M. Hall Collection, Sheldon Memorial Art Gallery, University of Nebraska, Lincoln, Nebraska.

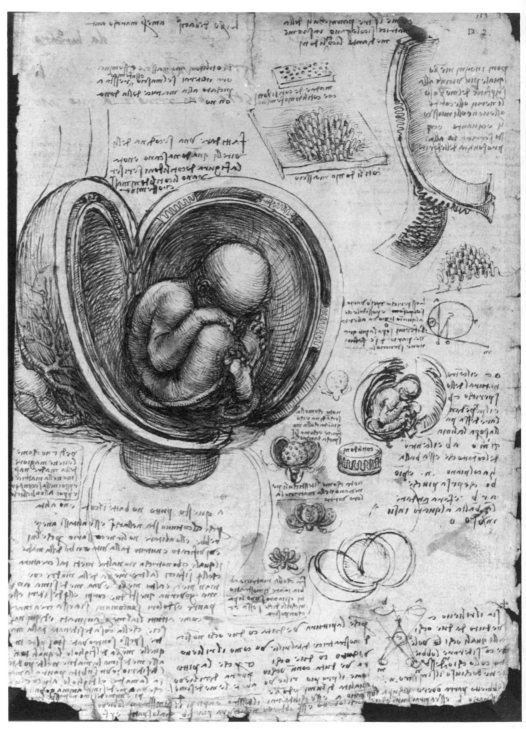

Leonardo da Vinci used red chalk for many of his early drawings, as well as pen and ink. Later, black chalk was his principle medium, one that he used throughout his life. In this drawing, red and black chalk were used with pen and brown ink. The chalk did not produce sharp, crisp lines, especially after repeated use on an abrasive drawing surface. Da Vinci used pen and ink lines to contrast with the soft marks of the chalk, and to help describe form.

Leonardo da Vinci, *The Infant in the Womb*, ca. 1510–12. Pen and brown ink with red and black chalk, 12″ × 8¹¹⁄₁₆″. Windsor Royal Library.

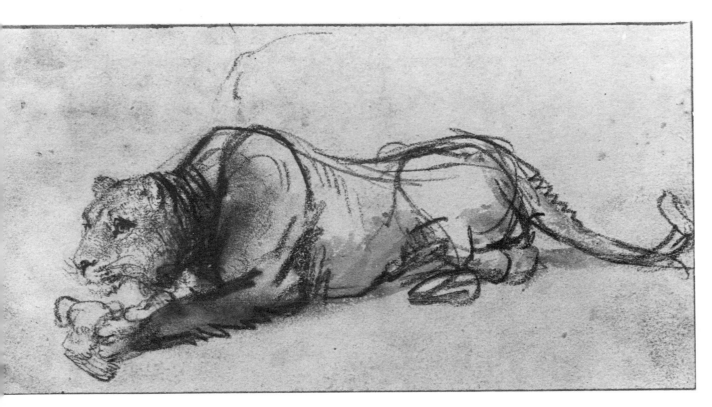

*Dutch artist Rembrandt Van Rijn stands as one of the
great masters of art. Chalk and sepia-colored wash
were used for this drawing of a lioness eating a bird.
The loose treatment of the chalk line contrasts with the
subtle rendering of the animal's head. The sharp lines
of the neck and hind legs suggest the use of a harder
chalk, perhaps charcoal. Make a series of drawings in
which rapidly-drawn areas contrast with subtle, sensi-
tive rendering.*
Rembrandt Van Rijn, *Lioness Devouring a Bird*, ca.
1641. Chalk and wash, 5¼″ × 9⁷⁄₁₆″. The British
Museum.

Pastels offer artists the opportunity to execute drawings rapidly in color. Some artists use pastels as underpainting; when pastels are sprayed with a fixative, the layers of pastel can be painted over using acrylic or oil paints. French artist Edgar Degas soaked pastels in steam. This sufficiently softened a thin outer layer of the chalk to produce an impasto quality. The vigorous application of pastel resulted in a rich textural surface that is painterly in appearance.

Edgar Degas, *Danseuses Roses*. Pastel on paper, 33″ × 22″. Museum of Fine Arts, Boston, Massachusetts, Seth Kettel Sweetser Residuary Fund.

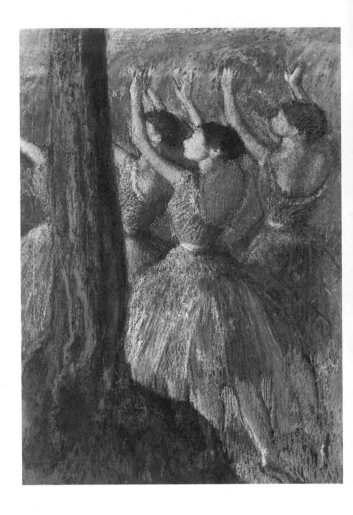

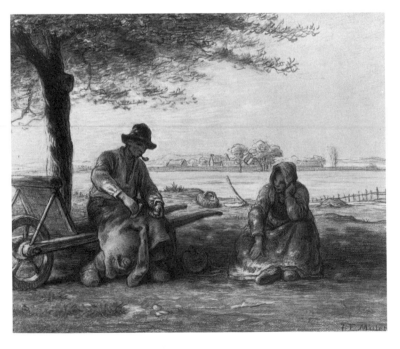

Semi-hard pastels are mixed with an oil binding agent that offers the artist advantages not found in ordinary soft pastels. With the addition of the binding agent, hard pastels will adhere to a wider range of drawing surfaces, producing the sharper lines for the detail many artists prefer. Various pastels were used alone and in combination with others by French artist Jean Millet to produce the many tints, tones and shades. On some areas of the drawing, values were produced by blending, then contrasted with line to separate one value from another.

Jean Francois Millet, *Peasants Resting*, ca. 1866. Pastel, 16¾″ × 20¼″. The Armand Hammer Foundation, Los Angeles, California.

Pastel is best characterized by the brilliance of pure, dry pigment. It offers the artist brightness similar to that of the original object. Often, works done with pastel are termed "drawn paintings." Rich colors are possible when pastels are used directly on the drawing surface, especially analogous colors (closely related) and complementary colors. Degas used complementary colors, oranges and blues, and yellows and violets, in this drawing.

Edgar Degas, *Laundress Carrying Linen*, ca. 1888–1892. Pastel, 24″ × 36½″ The Armand Hammer Foundation, Los Angeles, California.

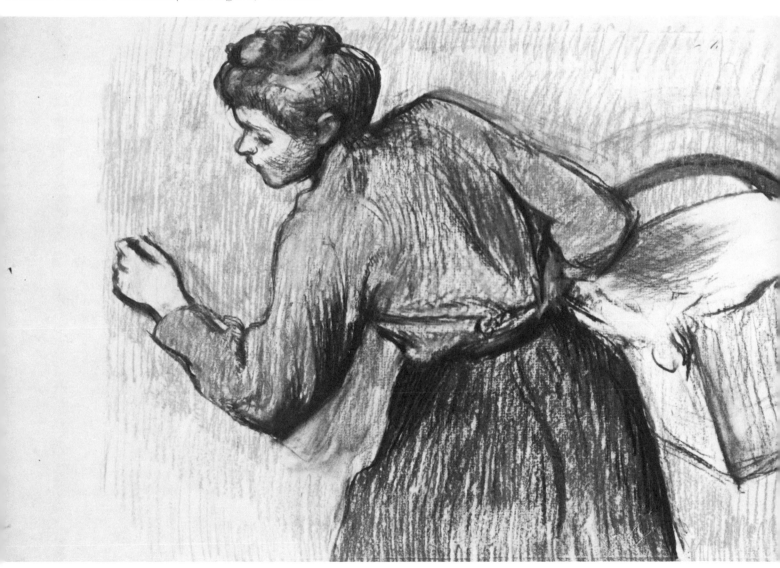

Anna Rodrigue

5

GRAPHITE

Graphite is available as long slender rods which are held in mechanical holders, or as thick flat or round graphite sticks. The sticks can be sharpened to points or wedge shaped tips, or broken in half and used on the sharp edges to make crisp lines.

Graphite is manufactured in many degrees of softness, providing a versatile range of line and value. Very soft and very hard graphite are hard to erase. Overworking them often produces a shiny surface that lacks spontaneity and freshness. It is difficult to apply additional media over the slick graphite surface for use in combined and mixed media drawings.

Liquid and powdered graphite purchased at hardware stores can be used as drawing media as well. Powdered graphite produces a slick, silvery surface and can be used as a value. It can be applied directly from the tube with a brush, a piece of cloth or a paper towel. Turpentine acts as a solvent for powdered graphite and produces a thin wash. **Turpentine is a dangerous solvent and needs adequate ventilation. Follow all manufacturer's safety precautions.** Liquid graphite (used to lubricate metal) can be used as a dark wash for mixed media drawings and with graphite drawings. The liquid agent of the graphite penetrates the fibers of the paper, dries quickly, and leaves a dark stain on the drawing surface.

In this chapter, the sequence suggests that you separate stick graphite from graphite pencils. Try holding and using graphite as you do the more controllable media such as charcoal, chalk, conte, crayons and pastels. Other information on graphite can be found in the chapter on pencils.

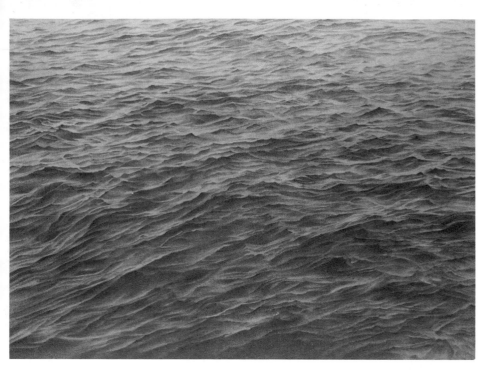

The ease with which graphite can be blended is demonstrated in this drawing by Viga Celmins. Light and dark values describe the movement of water. Graphite can also be worked with an eraser to suggest softened edges, highlights or to re-establish the white of the drawing surface. Celmins used graphite in a mechanical holder and sprayed selected areas of the drawing with acrylic spray, preserving portions of the underneath drawing for further work at a later time. Viga Celmins, Ocean Image, *1970. Graphite and acrylic spray, 14¼″ × 18⅞″. The Museum of Modern Art, New York, Mrs. Florence M. Schoenborn Fund.*

Graphite sticks can be broken in two and used flat, on the edges, or on their ends to produce various line qualities. Some graphite is manufactured in narrow sticks that can be sharpened to wedge points to produce line as well as value. Graphite is also available as round sticks. These, too, can be sharpened to a point. Round graphite does not require a mechanical holder.

Mechanical holders grasp thin rods of graphite that can be used with dull points or sharpened to produce delicate lines and subtle values.

American artist Jasper Johns made this drawing with hard and soft graphite, using different techniques. The light areas to the right and left were done with hard, flat sticks of graphite. Soft, pointed graphite produced the rapid scribble line and dark value. The full tonal range of graphite can be seen in the center of the drawing, achieved by altering pressure. Johns' drawing is based on ambiguity and does not necessarily impart the same meaning to all viewers.
Jasper Johns, *According to What*, 1969. Graphite on paper, 29¾″ × 41¼″. Leo Castelli Gallery, New York.

Round and flat graphite sticks were used here by artist Ramone Munoz. The graphite rods were used with a mechanical holder and describe the lighter valued skin tones. Softer graphite sticks were used for the texture and the darker values, creating an illusion of space behind the figure. Selective use of line separates similar values and defines the contours of the form. Ramone Munoz, *Torso*, 1984. Graphite, 11″ × 14″. Courtesy of the artist.

American artist Brad Davis developed this unique drawing using graphite and erasers. The artist first drew with soft, 6B graphite on a hard, smooth paper until shapes began to emerge and the image suggested a direction. The artist then vigorously rubbed the drawing surface with a gum eraser, softening the edges of the shapes and reducing the contrast between values. Finally, the shapes were clarified with graphite and a hard eraser, to unify the visual elements. Brad Davis, *Anya*, 1975. Graphite on paper, mounted on linen, 50″ × 96″. Courtesy of the artist/Holly Solomon Gallery, private collection.

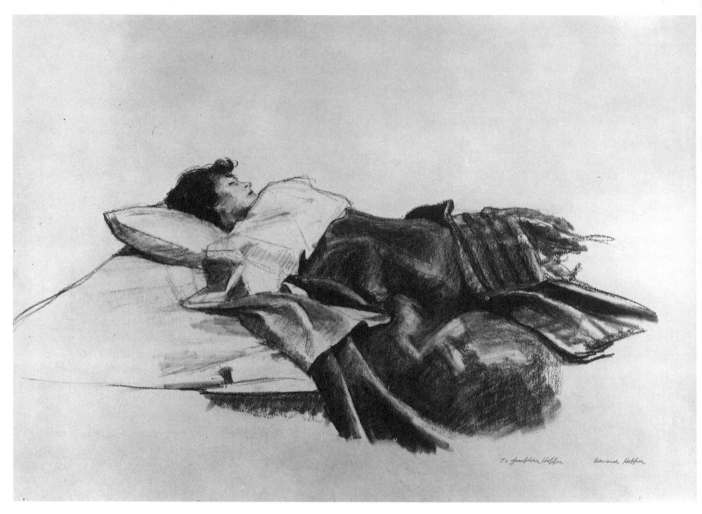

CONTE

Conte crayon is considered a chalk. It is a semi-hard drawing medium available in many shades and colors, including brown, sepia, bistre, sanguine (a Venetian red), black, white and grey. The latter are manufactured in several degrees of hardness.

The principle binding agent in conte is an oily substance that does not separate from the chalk or dust off the drawing surface easily. Thus conte provides good permanence. Conte is usually manufactured in stick form about one-fourth of an

inch square, and about three inches long.

Conte can be sharpened with sandpaper, kept blunt, or broken in half; using the broken tips, you can produce delicate, crisp lines. Turpentine and paint thinner can be used as solvents for harder conte crayons. Water is a better solvent for softer conte.

The crayons can be used with most dry, moist and wet drawing media as well as oil and acrylic pigments.

Some black, white and gray conte crayons have a harder consistency than sepia, bistre or sanguine conte crayons. The hard ones are no more difficult to use, however. Softer conte can be ground into dust and applied with fingers, thumbs, palms and small pieces of paper. It can be used with water, turpentine or paint thinner. Conte has been combined with dry, moist and wet media. Values can be produced when the side of the crayon is used. Lines are possible when the tips, corners and the edges of a broken conte stick are used.
Edward Hopper, *Jo Sleeping*, ca. 1940–45. Conte on paper, 15″ × 22⅛″. Whitney Museum of American Art, New York, bequest of Josephine Hopper.

Georges Seurat is remembered for his scientific method of painting and his magnificent conte crayon drawings. In this drawing, Seurat used cross-hatching and tightly packed parallel and swirling lines to create tone. He did not use value to describe round forms. Instead, the forms appear to emerge from the value. The linear cross-hatching produces a certain visual excitement on the entire surface. Try creating value using cross-hatching or repeated lines rather than with increased pressure on the medium. If need be, sharpen the conte stick with a blade or a sandpaper pad.
Georges Seurat, *Stone Breaker, LeRaincy*, 1881. Conte crayon, 12⅛″ × 14¾″. The Museum of Modern Art, New York, Lillie P. Bliss Collection.

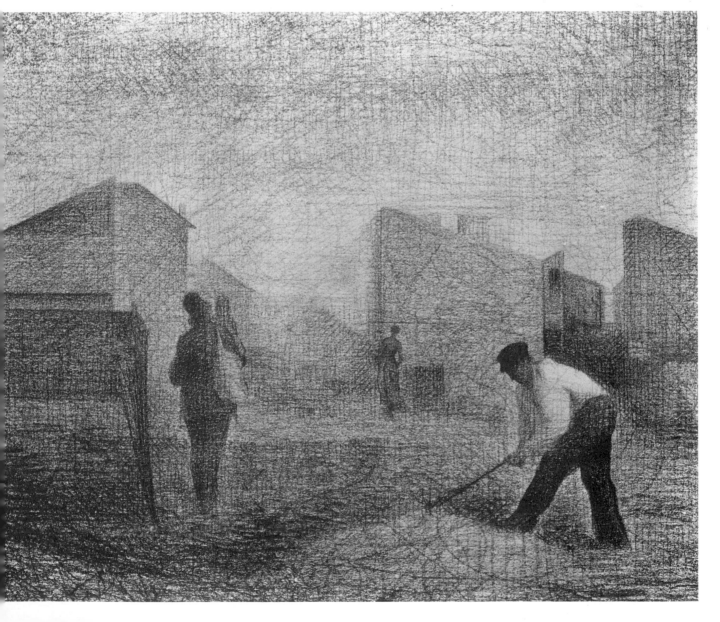

Sepia and sanguine conte are softer than black conte. The softer contes can be rubbed, smeared and blended to produce subtle values. Contrast can be achieved with less pressure, and by allowing more of the drawing surface to show through. With the addition of a few crisp, sharp lines, variation and interest may be increased in a drawing. Make a series of drawings of your hands, using hard and soft conte. Include accents of gray and white conte and lines with pencil, charcoal, or ink.

Linda Pearson, *Hand Studies*. Black and sepia conte, 20″ × 24″.

Conte crayon made with an oil binding agent can be controlled and used on a wider range of drawing surfaces. The harder conte crayons require consistent hand pressure in order to produce tone and line; a textured paper should be used with the harder sticks of conte. Try making a series of conte drawings of different objects. Compare the drawings done with hard and soft conte with those done with charcoal, chalk, wax crayons or graphite.

Charles Sheeler, *Feline Felicity*, 1934. Conte crayon on white paper, 21¾″ × 17⅞″. Fogg Art Museum, Harvard University, Cambridge, Massachusetts, purchase Louise Bettens Fund.

The softer conte sticks, sepia and sanguine, can be ground into dust, using the flat side of the medium against a rough surface. As with charcoal, preliminary drawings can be done using the dust applied with a piece of paper, fingers, thumbs and palms. Using a piece of paper about the size of your palm, fold the paper in half twice. Dip the folded end into the ground conte and liberally cover the folded portion of the paper with the dust. After some experimentation, you will be able to produce value and line using the corner, the fold, the edge and the flat side of the paper.

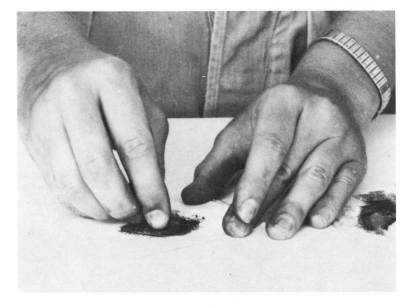

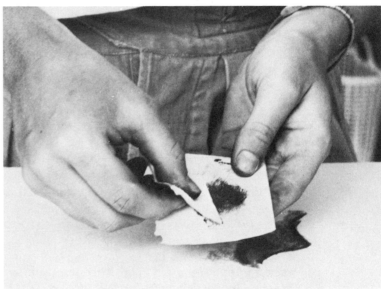

Using a piece of folded paper and the dust of sanguine or sepia conte, you can explore the medium, surface and subject matter without getting too dark too fast, and without filling in outlines that may be inaccurate. Keep your drawing hand and your folded paper moving on the drawing surface as you draw. Stop only to replenish the dust. Periodically, give emphasis to your preliminary drawing with line made by the corner or folded edge of the small piece of paper or with a conte stick. Remember, conte does not erase as easily as some other dry media you have used.

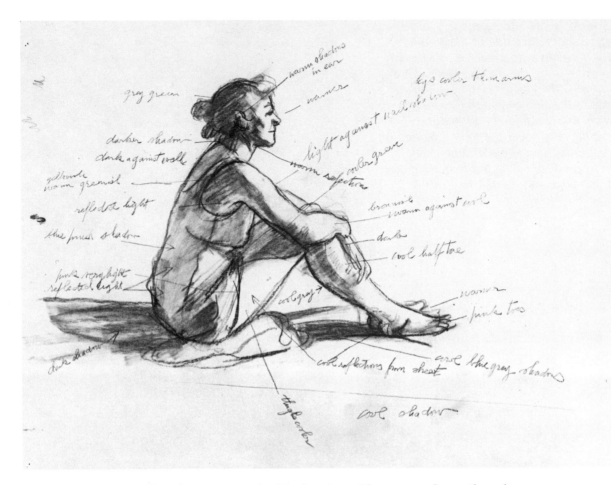

American artist Edward Hopper made this drawing with conte and pencil, and used it as reference material for a painting. On the left side of the drawing, you can see where the artist tested some conte as well as the hand pressure necessary to produce different values, before actually drawing. The pencil notations give valuable insight to the artist's thoughts as well as how he explored media, surface and subject matter. Some notations reminded the artist to use thick and thin lines, light and dark, and warm and cool colors for his painting. Edward Hopper, *Drawing for Morning Sun*, 1952. Conte and pencil on paper, 12″ × 18¹⁵⁄₁₆″. Whitney Museum of American Art, New York, bequest of Josephine N. Hopper.

This drawing was made with conte, graphite and acrylic pigment. The artist used the flat side of sepia conte for the initial stages. As the form developed, acrylic pigment was dry-brushed on certain areas of the drawing. The acrylic combined with or covered the conte. Soft graphite was used for additional value and line to help describe the form.
Jacqueline Saurez, *Figure*. Conte, acrylic, graphite, 18″ × 24″. Courtesy of the artist.

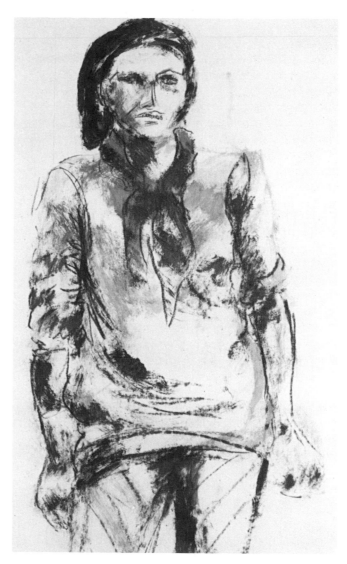

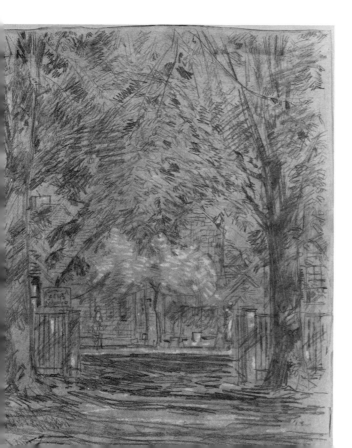

Childe Hassam made this drawing with conte crayon, pencil, and white; the pencil and crayon produced values that are balanced and unified. The hard pencil used to initiate the drawing did not yield sufficient contrast and prompted the artist to use the darker crayon to create an illusion of depth by advancing on the picture plane. The white pigment, perhaps gouache, describes a blooming tree as well as shallow space, due in part to the overlapping created by the two large trees on the right and left side of the drawing. Try re-creating this drawing; will your drawing motions be fast or slow? At what point did you introduce conte? What do the values made with hard pencil look like?
Childe Hassam, *An East Hampton Idyl*, 1923. Pencil, conte and white, 9″ × 7¾″. Courtesy Kennedy Galleries, Inc., New York.

The artist who made this drawing used several techniques while combining conte and ink. A preliminary drawing was done with conte dust applied with a piece of folded paper. This technique can be seen throughout the drawing. A wet watercolor brush was applied over the dry conte, producing a wash effect that can be studied at the top, left and in the middle of the drawing. The vigorous dry-brush effect seen throughout the work was produced by conte dust applied with a moist bristle brush. The brush handle was dipped in ink and used to help describe the form with a bold line.

Michelle LaRue, *Crouched Figure*. Conte, ink, 20″ × 24″. Courtesy of the artist.

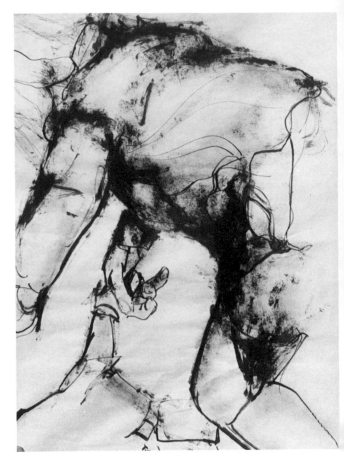

This drawing was made with conte and charcoal. These are quite compatible when used together. Conte is the lighter of the two media, and was used to begin the drawing. It is easier to draw from light to dark, rather than from dark to light. On this drawing, charcoal was used on middle and distant forms, while the brown paper and sanguine conte were used to suggest those forms that are closer to the viewer.

Wendy Shon, *Reclining Figure*. Conte and charcoal on brown paper, 24″ × 36″. Courtesy of the artist.

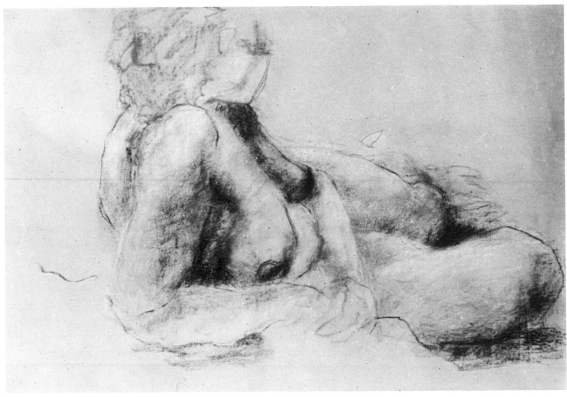

46

This image was made by drawing directly on brown paper with the side and point of a stick of sanguine conte. As the drawing developed, traces of brown and black conte were used. Charcoal and oil pigments were then applied for additional dark values and to suggest a figure in shallow space. The artist used overlapping, with value and line as the principle visual elements of the composition.
Kyumin Lee, *Reclining Figure*. Conte, charcoal and oils on brown paper, 32″ × 36″. Courtesy of the artist.

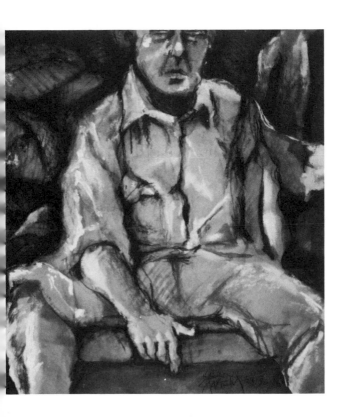

This drawing was begun with conte dust applied with a piece of folded paper, followed by work with conte and charcoal sticks. Earth-colored acrylic pigment was then dry-brushed over the dry media after they were sprayed with a clear acrylic fixative. Those areas not sprayed were drawn into using additional conte and charcoal, and acrylic washes made with water. These provided additional values. The rich values can be seen behind the neck of the figure.
Sean Maytum Portrait of a Man. Conte, charcoal, acrylic, and wash on brown paper, 30″ × 36″. Courtesy of the artist.

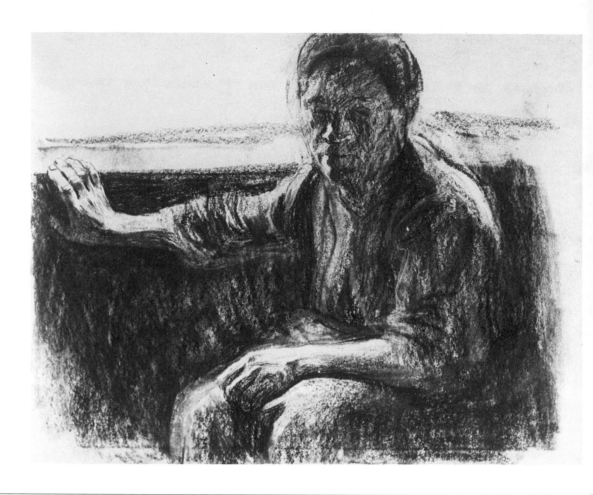

7

WAXY MEDIA

Crayon

Before the 19th century, it was difficult to find examples of crayon drawings. Ancient artists used a form of crayon made by soaking charcoal sticks in melted resin and wax. When artists desired softer crayons, charcoal was soaked in wax, tallow or even butter!

The wax crayons so familiar to most of us are actually made from paraffin mixed with dyes. These have improved in quality in recent years. Today crayons are longer lasting, made in a large variety of colors, values, and intensities, are generally less messy than charcoal and chalks and can produce a wide range of line and value. Crayons can be used with other chemically compatible media. Turpentine and paint thinner can be used to dissolve crayons, producing painterly effects.

The binding agents used to make crayons determine their sticking power. Today's crayons are harder to erase, but can be applied in layers until several layers can be distinguished. This allows the artist to rework drawings.

Ordinary wax candles, clear paraffin wax, or light colored crayons can be used for resist drawings. A thin wash of ink or watercolor will stick only to areas that have no wax. The wax and the wash can be drawn into with pen and ink. Grease pencil, charcoal, conte, chalk and oil pastels are all compatible with crayons.

Many artists use paraffin wax crayons for drawing because they are easy to obtain and versatile. Wax crayons and conte crayons both rely on oil-based binding agents. Wax crayons are softer and have greater sticking power, requiring pronounced hand pressure to produce values and to accumulate enough of the medium on the surface. In this drawing, Kathe Kollwitz used black crayon on brown paper, reducing the contrast of the drawing. This creates an illusion of shallow space. White pigment was used for highlights and to define form.

Kathe Kollwitz, *Woman on the Bench*, 1905. Crayon and Chinese white on brown paper, 19½″ × 24½″. Copyright 1959, Galerie St. Etienne.

This drawing by Pablo Picasso was a preliminary study for the painting Family of Acrobats. It differs considerably from the final painting. Some drawings are only a means to an end. The exploratory nature of drawing encourages artists to research the visual elements until the direction the drawing takes is more defined, and form begins to emerge. This type of drawing is seldom erased because doing so destroys valuable information necessary to the artist. Picasso used hard crayon to explore the elements of line and value.

Pablo Picasso, *Mother and Child and Four Studies of Her Right Hand*, 1904. Black crayon on tan wove paper, 13½″ × 10½″. Fogg Art Museum, Harvard University, Cambridge, Massachusetts, bequest Meta and Paul J. Sachs.

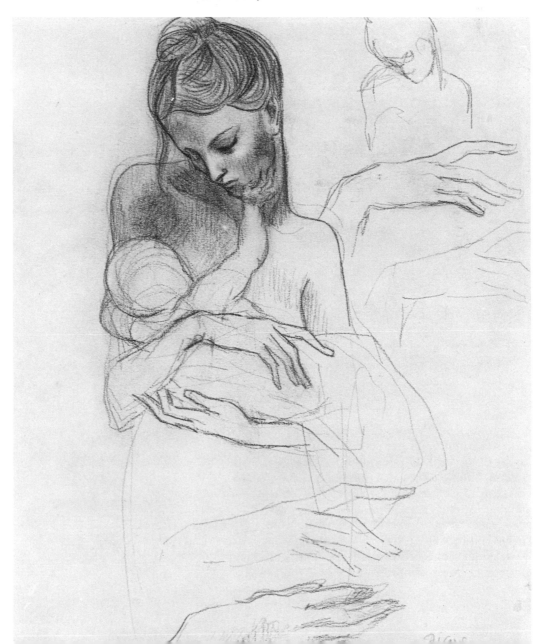

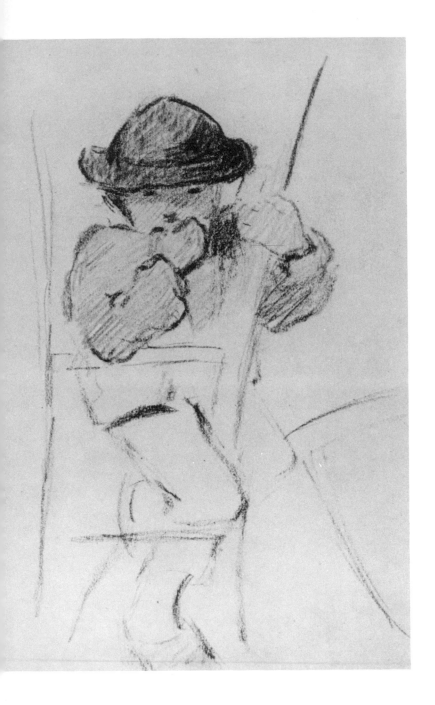

This little drawing was part of a sketch book containing 268 small sketches. Many of the images were used as information for subsequent paintings. A charcoal pencil was used first, followed by crayons. The soft, flaky, medium of the pencil is quite compatible with waxy crayons. The artist, Paul Gauguin, drew with red, blue and traces of orange crayon over the charcoal lines and value, especially on the upper part of the drawing.
Paul Gauguin, Pages from Breton Sketchbook, No. 16, *Little Breton Boy* (100.4 recto), ca. 1884–88. Crayon and pencil, 6½" × 4¼". The Armand Hammer Foundation, Los Angeles, California.

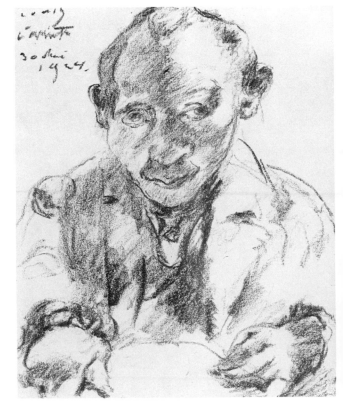

Artist Lovis Corinth used the side of a black crayon with consistent hand pressure to produce the related values of the face, chest and arm. Some areas of the drawing have darker values produced by increased pressure, as well as line for additional contrast. Make a drawing using crayons of different colors. Use one color each for near, middle and distant forms.
Lovis Corinth, *Self-Portrait*. Black crayon on white wove paper. Fogg Art Museum, Harvard University, Cambridge, Massachusetts.

Crayons can be used in short or medium lengths. Remember, as the drawing implement lengthens, the degree of control lessens. Peel off the protective paper so you can use the side of the crayon to produce broad areas of value. Break the crayon in half and use the sharp edge of the break to produce crisp lines. You may want to sharpen the edge as it wears down. Crayons can be used with turpentine and bristle brushes or simply dipped into turpentine and drawn with while the crayon's surface layer is being dissolved. The amount of texture on a drawing can be controlled by increasing or decreasing the amount of protection underneath the drawing surface. More protection will ensure a smooth drawing surface, whereas less will produce a rough texture on the drawing.

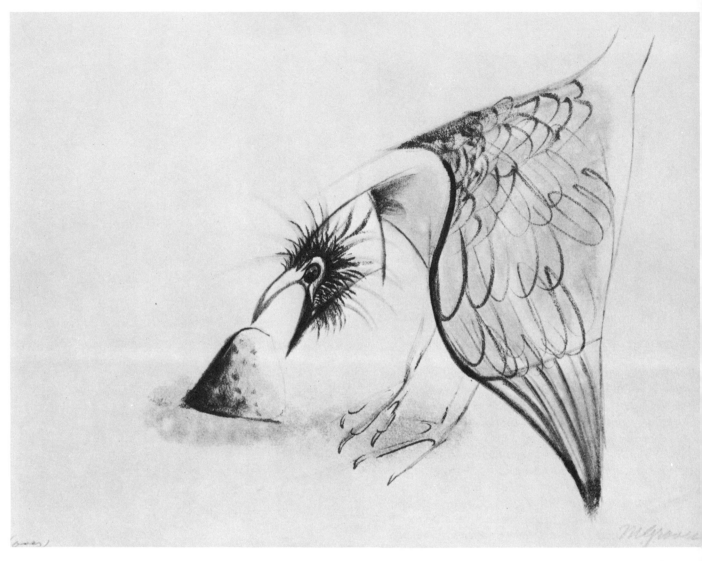

Morris Graves used line as an expressive element. Here
rapidly-drawn crayon lines describe the ruffled feathers
of the bird and give additional emphasis to the image
of the angry bird. A brush loaded with ink produced
the dark value of the face and the edge of the wing.
Try making a series of drawings of imaginary birds or
animals using rapid and slow gestures. Then compare
both techniques.

Morris Graves, *Bird Attacking A Stone*. Crayon, brush
and ink, 10⅜″ × 13⅜″. Museum of Fine Arts, Boston,
Massachusetts, Abraham Shuman Fund.

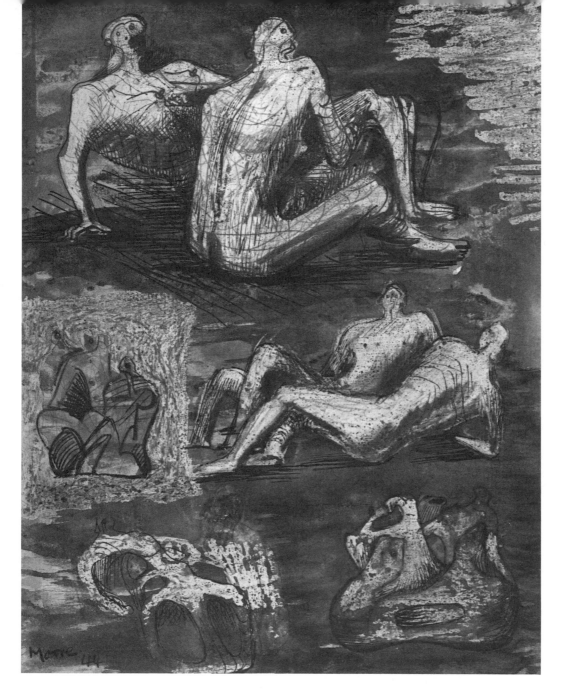

An exciting drawing technique was explored by artist Henry Moore in this wax resist drawing. For this technique, use light-colored crayons, wax candles, or clear paraffin wax over white or light-colored paper. The initial stage of your drawing will be difficult to see. As the drawing progresses, draw with other media such as pencil or pen and ink. Apply watercolor or ink washes over selected areas of your drawing, lightly at first, preserving the underneath drawing, and as the light washes dry, apply dark washes or drawing ink. As you do so, become receptive to areas of wax that can be scratched into (sgraffito) with pen and ink line to bring forms into focus.

Henry Moore, *Ideas for Two-Figure Sculpture*, 1944. Crayon, pen and ink, pencil and watercolor, 8⅞" × 6⅞". The Museum of Modern Art, New York, purchase Abby Aldrich Rockefeller.

Oil pastels were applied here in a traditional manner. The artist drew diagonal areas of value and line with individual pastels, or combined and overlapped colors to produce unique hues. The alternation of light and dark values suggests depth and dimension.
Maryrose Mendoza, *The Kitchen Sink*. Oil pastel, 20″ × 24″. Courtesy of the artist.

Oil Pastels

Oil pastels are a relatively new drawing medium.
They are often mistakenly referred to as wax
crayons. Oil pastels are made with a combination
of pigments, an oil binding agent and an occa-
sional mixture of wax. They are generally greasier
than crayons, and oil pastels do not hold a sharp
edge. As a result they are relied on for producing
value and wide, soft-edged lines. Because the pig-
ment is contained in an oily substance, oil pastels
are less crumbly than many other media. They
will not smear unless strong pressure is applied.

The main virtue of oil pastels is that they do not
rub off the drawing surface, nor do they rub in
with ease. Pressure changes are necessary. It is
easy to build up oil pastel layers too fast.

The binding medium in oil pastels will dissolve
in turpentine or paint thinner. This can be used as
a light-colored wash. An oil pastel dipped in thin-
ner yields a rich drawing medium. Oil pastels can
even be partially dissolved in thinner and brushed
onto paper using bristle brushes. Various resist-
and-scratch techniques work well with oil pastels.
The possibilities are many. Oil pastels invite
exploration in combinations with other dry, moist
and wet media.

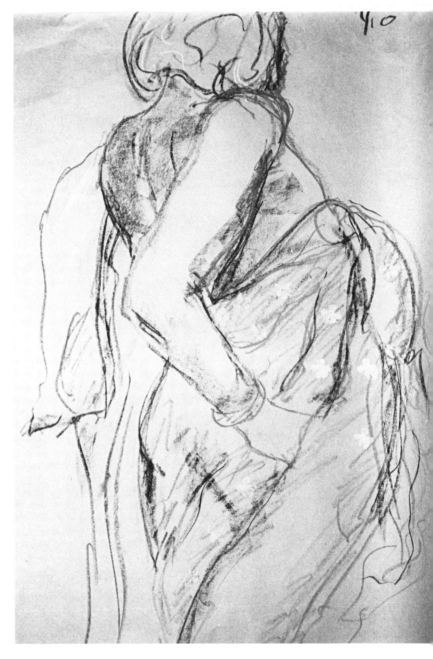

*This drawing combines oil pastels, conte and an eraser
print. The flat side of soft bistre conte was used to sug-
gest value and to create the crisp lines. These are easy
to distinguish from the softer, fuzzy lines made with
pastels. The delicate flowered print of the fabric was
created using acrylic pigment applied with a rubber
eraser that was cut and used as a stamp.*
Nicole Wyatt, *Draped Figure*. Oil pastel, conte,
stamped acrylic, 30″ × 36″. Courtesy of the artist.

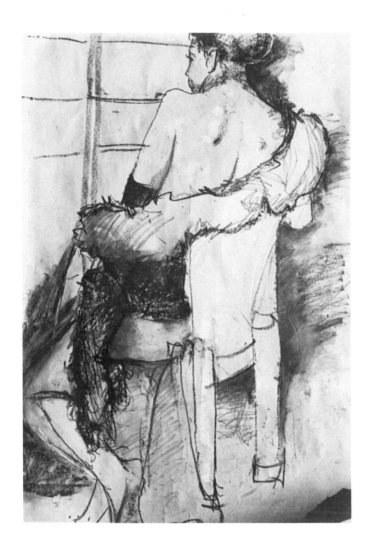

This drawing was created using oil pastels in a wide range of hues. The colors were combined with turpentine and applied with a stiff bristle brush. Then the artist rubbed with fingers on selected areas of the composition with a cloth. Try drawing with oil pastels on different surfaces. Include rough and smooth surfaces, as well as paper, canvas and board.
Roberto Baldwin, *Seated Figure*. Oil pastel, 24″ × 30″. Courtesy of the artist.

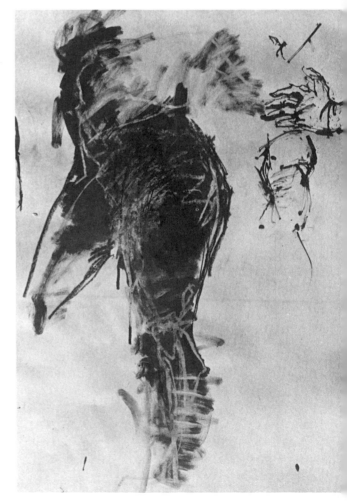

Oil pastels can be used for resist drawings. The preliminary stages of this drawing were done with a blunt light-colored pastel; note the thickness of the line. The oil-based binding agent of the pastel resists the watercolor wash. In this drawing, the dark watercolor was resisted by the gray oil pastel, producing ample contrast for the drawing.
Dag Compeau, *Marathon Runner*. Oil pastel, wash, 12″ × 16″. Courtesy of the artist.

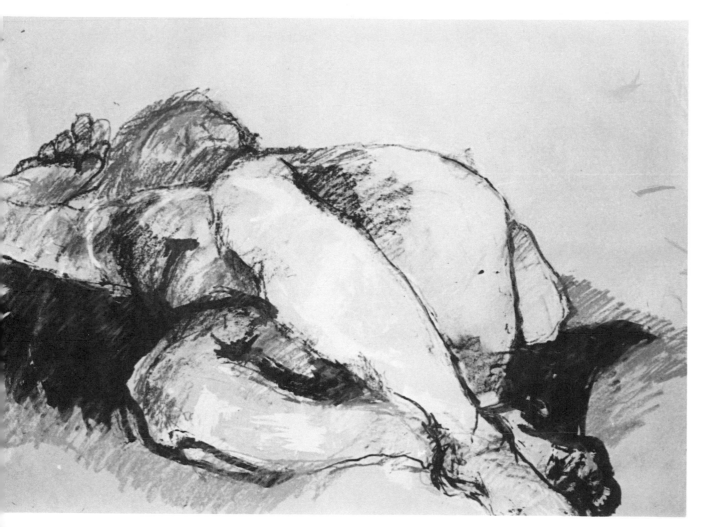

Wax crayons and oil pastels are chemically compatible, and can be used together. Oil pastels are softer than paraffin wax crayons. Both can produce value, texture and line, but oil pastels yield a softer line. The initial stages of this drawing were done with crayon, followed by oil pastels. Traces of conte were used as the drawing developed. As a final touch, the artist brushed in a water wash of sanguine conte to suggest the flesh tones of the figure.

Maryrose Mendoza, *Reclining Figure*. Oil pastels, crayon, acrylics, 24" × 32".

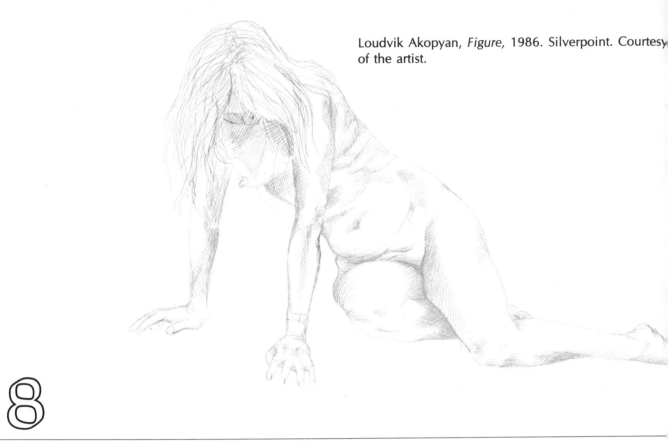

Loudvik Akopyan, *Figure,* 1986. Silverpoint. Courtesy of the artist.

8

PENCIL AND METALPOINT

Pencil

Pencil is one of the more familiar and more readily available drawing media. Many of us learned to write with pencils and we often scribble, doodle and draw with them.

Graphite pencils are often mistakenly referred to as "lead" pencils from the earlier use of metallic points such as lead and lead alloys. Silver, gold and brass were used as well by Renaissance artists. Many preferred to draw with silver wires for the rich values these produced.

Graphite is the medium used in pencils. It was first discovered and cut from mines in England about seventy years after Columbus sailed for the New World. The export of graphite was closely monitored by the English. This created a shortage of graphite for artists. As a result, a French artist named Nicholas Conte was asked to experiment with inferior graphite in hopes of developing a

suitable drawing medium. He combined fine clay, graphite and heat to make cylindrical rods that were inserted into hollow pieces of cedar wood. Thus the pencil was born.

Conte is acknowledged as the inventor of the pencil. However, pencils as we know them were not perfected until the late 18th and early 19th centuries. Today, it is possible to purchase graphite pencils in more than twenty degrees of hardness. They can also be made with carbon, wax, conte, charcoal, grease and in many colors. Leads can be made soluble in water or other solvents or insoluble. Pencils can be combined with many other media, including charcoal, crayons, conte, ball-point pens, markers, ink, ink washes, watercolor, turpentine, acrylic and oil pigments.

Make a series of drawings using graphite pencils. Use both hard and soft graphite. Some subjects you might want to draw in the series are wood, leather, plastic, cloth, wrinkled foil, metal, plastic and natural forms. What differences do you notice between hard and soft graphite? Which is easier to erase? Which produced the most contrast? What happens to graphite when it is rubbed excessively?

Helen Wong. Graphite pencils. Courtesy of the artist.

59

The pencil can be thought of as an extension of your index finger. Your finger controls the pencil, using the point to produce lines and the side to produce values. Experiment with ways to hold the pencil until it feels comfortable in your hand. Try using soft and hard leads on a variety of rough and smooth papers. Try tying or taping a short pencil stub to your index finger and drawing with it. Can you control the marks as easily?

Drawing implements such as pencils, pens, markers and brushes can extend beyond the finger tips a considerable distance. They produce lines, values and textures that are less controlled, more spontaneous, and have more variation, compared with the marks produced by shorter drawing implements. Try using soft pencils on a medium rough surface for this technique.

Pencils can be made to produce values when the side is used. Broad strokes will deposit more of the medium on a wider area of the drawing. By using a textured drawing surface, more graphite will accumulate, producing darker values. Soft pencils can produce a wide tonal range as well as line. Harder pencils, however, will yield subtle values and are best suited for line drawings. For drawings done with hard pencils, use a smaller format, to compensate for the lack of contrast.

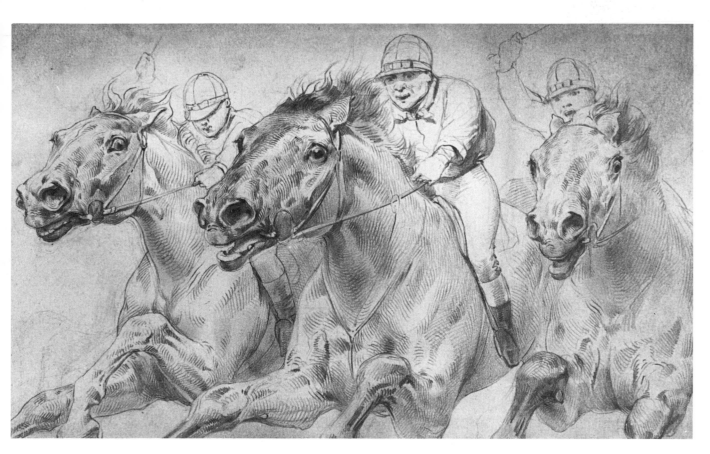

American artist Louis Maurer used short, slightly curved lines to describe three racing horses. Some lines were drawn close together and others were cross-hatched to produce dark values, creating an illusion of roundness. Areas of the drawing have also been rubbed lightly to produce middle tones, unifying the darks and lights of the drawing.
Louis Maurer, *Horse Race*. Pencil on paper, 7¼″ × 13¼″. Museum of the City of New York.

Cross-hatching is another technique artists use. It is achieved by drawing lines parallel and across each other. The lines may be close together or widely spaced to produce value, depth, dimension or to describe a change in form. Cross-hatching allows the artist to create form and value quickly on a drawing.

This drawing pencil, sometimes referred to as a sketching pencil, has a rectangular lead. Unlike pointed pencils, more line variation is possible. By rotating the pencil as you draw, you can create thick and thin lines. These help describe near and far forms on the picture plane. A wide range of values is produced with soft lead pencils. Sharpen this kind of pencil with a knife or blade, keeping the lead rectangular.

A drawing pencil with soft, wide, rectangular lead was used to make this drawing of a seated figure. Unlike pencils with round points, the wide graphite can produce thick and thin lines as well as value. Graphite was allowed to accumulate on the surface of the paper, rubbed with a paper towel, and then drawn into with a soft eraser to re-establish the value of the drawing surface. You can study this technique on the left side of the drawing. Contrasting conte line helps describe forms and separates similar values on the drawing.

Chelsea McGraw, *Seated Figure*. Graphite pencil, conte on brown paper, 12" × 13½". Courtesy of the artist.

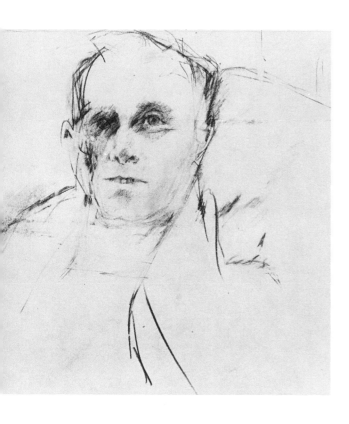

Artist Larry Rivers used a charcoal pencil on a textured drawing surface. The lines that describe the form were drawn rapidly and with enough pressure to produce broad, dark strokes. Areas of light values have been made with the side of the pencil point and with less pressure. Try to imagine yourself making this drawing. Is your pencil held near the tip or the end? Are your strokes fast or slow? Are you concerned with minute details?

Larry Rivers, *Portrait of Edwin Denby*, 1953. Pencil, 16⅜″ × 19¾″. The Museum of Modern Art, New York, given anonymously.

Childe Hassam used a soft graphite pencil to produce these rapidly-drawn parallel lines. On this drawing the artist suggested nearness by allowing more of the paper to show through the pencil lines. He created depth where the lines are drawn closer together, producing dark values. Cross-hatching also allows the artist to visualize form and value much sooner.

Childe Hassam, *Against the Light*. Pencil and white wash. The Art Institute of Chicago, Carter H. Harrison Collection.

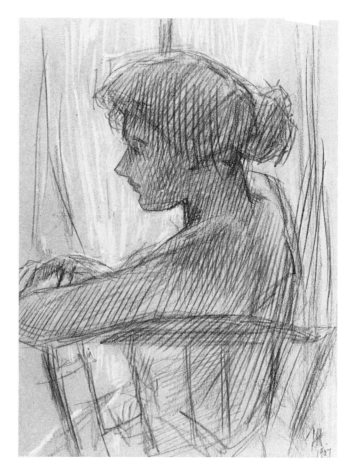

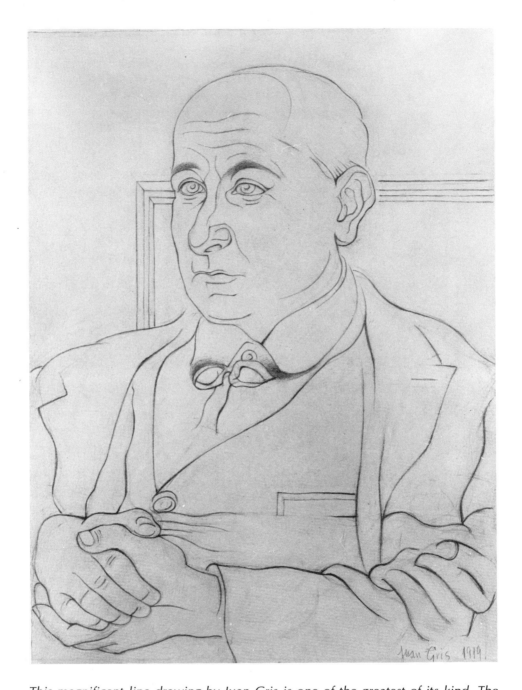

This magnificent line drawing by Juan Gris is one of the greatest of its kind. The artist made a series of decisions about line that proved to be correct, with no need for further exploration. Precision, clarity, exactness of representation are all evident. The artist did not rely on value to suggest roundness but on rotation of line to achieve form. A soft pencil was used to make the drawing.
Juan Gris, *Max Jacob*, 1919. Pencil, 14⅜" × 10½". The Museum of Modern Art, New York, gift of James Thrall Soby.

A sketching pencil can be used as a long or short drawing implement. When held near the tip, value and line can be closely controlled. The pencil also can be held near the end and used as a probing tool, guided by the index finger to produce thick and thin lines. Make a slow scribble drawing and a fast one on one sheet of paper. Compare both drawings and select the most interesting one. Now make a third drawing by placing a piece of tracing paper over the drawing. Use pen and ink on the third drawing. Concentrate on eliminating unnecessary lines, and move the drawing in the direction of a single contour line. Look at the scribble drawings of Alberto Giacometti on pages 73–74.

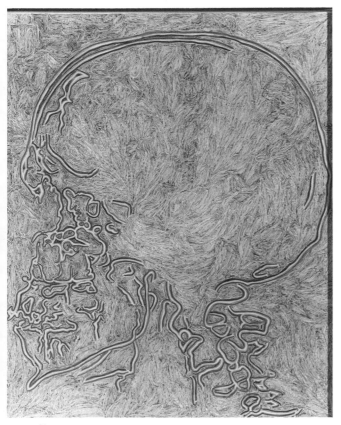

Thousands of colored pencil lines make up this drawing by Lucas Samaras. The patterned lines resemble the furrows of a plowed field seen from the air. They contrast with the ink outline of the skull. Several types of colored pencils are available offering exceptional strength and brilliance. When solvents are brushed onto soluble colored pencil work, a colored wash can be produced. Try drawing into a pencil drawing with pen, ink and markers for additional variation.
Lucas Samaras, *Large Drawing #4*, 1966. Colored pencils and ink, 17″ × 14″. The Pace Gallery, New York.

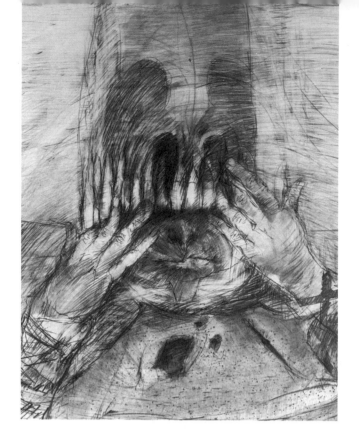

Mauricio Lasansky created a series of powerful symbolic drawings based on man's inhumanity to man. They were done with pencil, earth colors and turpentine wash on large sheets of paper. Some of the drawings in the series measure six by four feet. The rapidly-drawn pencil lines fuse with the turpentine washes and give the drawings additional dimension. Contrast was achieved here with the vertical lines of the skull-helmet and light values of the hands and face. A stipple technique was used for the visual texture. You will discover that turpentine washes are chemically compatible with oil pigments. Acrylic pigments can be used for this technique when water is used as the solvent to produce washes.
Mauricio Lasansky, *Nazi Drawing #21*, (detail), ca. 1961–1966. Lead pencil, turpentine base, red water-base earth color, 76″ × 35″. The University of Iowa Museum of Art, on loan from the Richard Levitt Foundation.

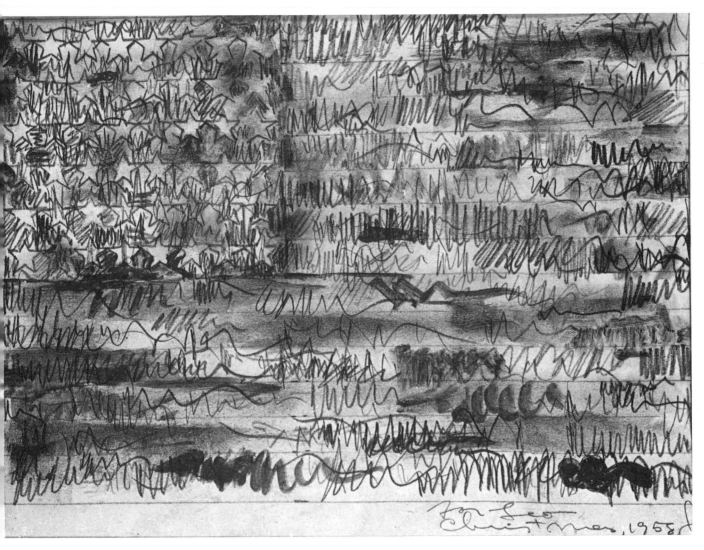

Medium and soft graphite pencils were used for this drawing by American artist
Jasper Johns. Lightly drawn lines suggest the horizontal stripes of the flag. These
contrast with the wavy lines drawn with a softer pencil. Liquid and powdered
graphite were used for additional values. In liquid form, the dark graphite was
absorbed by the drawing surface. Powdered graphite was used dry and rubbed
onto the drawing surface, producing a soft, silvery value. Try drawing over liquid
graphite with a graphite, grease or charcoal pencil.
Jasper Johns, *Flag*, 1958. Pencil and graphite wash on paper, 7½″ × 10⅜″.
Courtesy Leo Castelli Gallery, New York.

Metalpoint

Metalpoints as drawing implements preceded graphite pencils by hundreds of years. Like many art media, metalpoints were adapted for artistic purposes after serving other professions and trades. Metalpoints were used by medieval scribes for texts and ornamentation on the leaves of manuscripts. Artists of the late Middle Ages and the Renaissance used metallic points widely.

Metalpoint media include a wide range of metallic substances and silver, gold, copper, lead, tin, alloys of brass and bronze and lead tin. These are often mistakenly referred to as silverpoint, due in part to the popularity of that metal with artisans. Silverpoints yield excellent results on a variety of prepared surfaces.

Metalpoints fell out of favor with artists with the invention of graphite pencils. Pencils required less preparation, were easier to use and generally produced results that were comparable to the rich value and line of metallic points.

You can make a stylus from any one of the metals listed above. If the metal is in thin wire form, insert it into a mechanical pencil or mechanical holder designed for a graphite rod. You can also tape or tie a metal wire to a wooden dowel, pencil or discarded brush handle, or tightly wrap brown paper around the length of wire until a suitable thickness is achieved.

File the end of silver, brass or copper wire to a rounded point and smooth it with emory paper and steel wool. Do not make the point too sharp as it may perforate the specially prepared paper. Several surfaces, including parchment, cloth, vellum, and smooth masonite, can be prepared by coating with thin layers of gesso. For drawing purposes, a heavy smooth matte paper is best. Watercolor paper is best immersed in water and taped to a board with brown paper tape and allowed to dry.

The paper surface must be coated with a material that will accept the traces of metal and make them visible. Gouache, zinc white and titanium white pigments can be used, but gesso is perhaps the easiest and most convenient material used today. The white pigments can be tinted with other pigments for an additional dimension to metalpoint drawings.

Metalpoint drawings are accomplished by leaving traces of metal on the surface of the ground. The drawing strokes are light in value. Don't be concerned with pressure or the side of the wire, since these aspects have little effect on the drawing. Because of the subtle qualities of metalpoint drawings, it is best to draw on smaller surfaces.

Pei Ling, *Apples*, 1986. Silverpoint, 4" × 7". Courtesy of the artist.

Cu Tran. Silverpoint, 6" × 8". Courtesy of the artist.

Coat a piece of paper with at least four thin layers of gesso, avoiding brush strokes when possible. Allow to dry and begin drawing with a metalpoint. Metalpoints will not blur and cannot be worked with erasers. The surface can be recoated with gesso to alter the drawing. Silverpoint marks resemble those of a hard graphite pencil. Values can be achieved by cross-hatching lines or by placing marks close together for mid-range and distant objects and farther apart for closer objects.
Cu Tran. Silverpoint, 6" × 8". Courtesy of the artist.

The value range of metalpoints is relatively light and cannot be altered by pressure on the point. Lead and lead alloys will produce the darkest marks. Try drawing with ordinary lead type. This silverpoint drawing was done on a small format surface and suggests a wide value range because of its size. The values of many metalpoint drawings lighten with age and turn brown or yellowish in color.
Loudvik Akopyan, Il Gatto. Silverpoint, 4" × 5". Courtesy of the artist.

9

SELF-CONTAINED PENS

Ball-Point Pen

Ball-point pens use an ink made with aniline dyes. The ink is an oily liquid that combines with the drawing surface. The inks have the sticky consistency of glue and are rolled onto the surface by means of a small ball in the tip of the pen. This design provides a continuous flow of ink, as long as there is moist ink in the barrel.

Ball-point inks do not provide the rich, opaque value of India inks. There is some doubt about the permanence of ball-point inks, too, especially after prolonged exposure to strong light. Apart from the minor disadvantages, ball-point pens are excellent for drawing small sketches. These pens can produce delicate lines that resemble traditional pen drawings made with flexible metal points. Ball-point pens are very well suited for scribble draw-

ings. Random lines, drawn in many directions, can describe form and value beautifully. Drawings of this style reach their potential sooner with the continuous ink supply of the ball-point pen.

When drawing with ball-point pens, the ink solution dries quickly by evaporation. This leaves a permanent mark on the surface. Ball-point ink is very sensitive to alcohol and thinner. The ink will run or fade if it comes in contact with these solvents.

Ball-point pens can be used with other dry media, providing the other media are applied over the ball-point drawing. Ball-point ink will not stick if applied on top of most other media. Wet media, the washes and watercolors, are effective with ball-point inks, as are the acrylic and oil washes.

This drawing is indicative of the control possible using a ball-point pen held close to the tip. Patterns, lines, textures and values have been faithfully rendered in this surreal drawing.
Scott Wills, *Untitled*. Ball-point pen, 16″ × 20″. Courtesy of the artist.

This page of thumbnail sketches was drawn in a brief period of time. The average drawing took about four seconds. The constant moving of the subject matter forced the artist to look more critically, react faster, and use only essential lines to describe the form. Anissa Boudjakdji, *Cats*, 1984. Ball-point pen, 6″ × 9″. Courtesy of the artist.

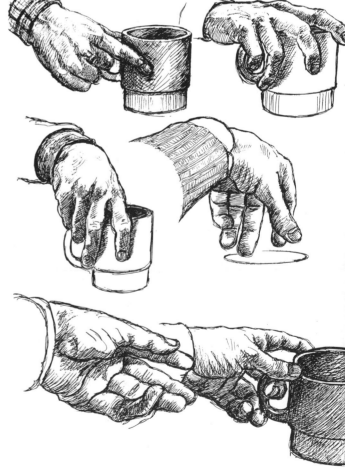

Ball-point pens are light, portable, readily available, and provide a continuous ink supply. The size of a ball-point line suggests that you use a small drawing surface, perhaps sketchbook size. These hand studies are done in a traditional pen and ink manner. They emphasize cross-hatching to produce value. Alfredo deBatuc, *Hand Studies*. Ball-point pen, 8½″ × 11″. Courtesy of the artist.

Try making a small wire sculpture with thin wire. When it is complete, draw only those essential lines that describe the form. Use a continuous line. Emphasize the lines that can be rotated to achieve more depth and dimension in your work. Use this exercise to gain an insight into contour line drawing.

Alberto Giacometti used red and blue ball-point pens on this drawing. He drew with red ink over the blue to clarify the form. In a sketchbook, make a series of drawings using a scribble technique and ball-point pens. Try to determine the near, distant, and middle-distant forms, describing them with different colored inks. Use the light ink for the near forms, a middle value ink for the mid-distant forms, and a dark ink for the distant forms. Work fast, allowing your line to explore, overlap and wander. Limit your drawing time to brief periods, perhaps from ten seconds to two minutes.

Alberto Giacometti, *Trois Tebes.* Ball point pen, 8⅛" × 6". Courtesy Pierre Matisse Gallery, New York, photo Eric Pollitzer.

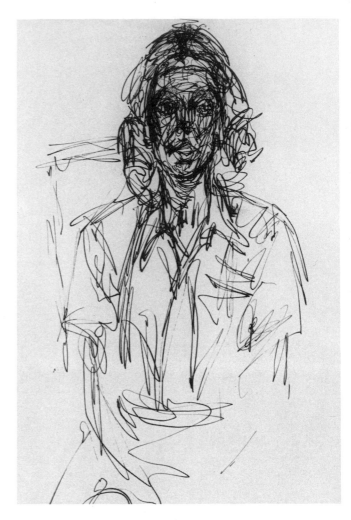

These two scribble drawings were made by Alberto Giacometti. He used ball-point pens and rapid drawing motions to create the expressive character of the line. The pen was held away from the point, using more wrist action and less finger control. Areas that required more clarification were drawn with the finger tips closer to the pen point, almost like writing. The expressive quality of line can be enhanced with quick drawing gestures, holding the pen far from the point. Can you identify the drawing in which rapid motions were used, and the one where more control was achieved?

Alberto Giacometti, *Nu Assis (Annette), Still Life.* Ball-point pen. Courtesy Meckler Gallery, Los Angeles.

Markers

When felt-tip markers were introduced to artists less than forty years ago, their fluid was actually a dye that dried instantly, giving off a very pungent odor. Despite the minor flaws in their design, the first felt-tip markers created a revolution in drawing. They offered a way to produce a line that is something between that of a brush and a ball-point pen. Markers can be held near the tip or far from the tip, to gain or relinquish control over the drawing surface.

As plastics were developed, they were integrated into the making of drawing implements. Today, markers are manufactured with several different styles of tips. These include felt, steel and nylon. Nibs may be wide, narrow, chisel edge or flat. The style of the nib determines the quality of line produced. Felt-tip markers make a soft, diffused line, and differ from metal, plastic or nylon nibs. Experiment with different nibs, and choose those that are best suited to your style.

Fine-line markers are best suited for drawing in a traditional pen-and-ink manner. Markers offer a constant ink flow that does not have to be replenished by frequently dipping into an ink supply.

With markers, lines can be varied by the amount of pressure applied. Heavy pressure will produce a thicker line. For greater variation, some markers have interchangeable tips and refillable cartridges. Dried tips can usually be revived by wetting with the proper solvent. Some drawings can be enhanced when the lines are drawn with a dry tip, taking advantage of the texture as an added dimension of the drawing.

This drawing was done in a traditional pen and ink manner, with marks characteristic of those produced with nylon-tipped markers. Nylon, plastic, felt and wood produce marks different from those made by metalpoints. Dots, dashes, cross-hatching and line variation are all evident in this drawing. Try making a series of drawings of your immediate environment. Use colored markers with a variation of points. Experiment with colored paper as well as white paper.

Anna Hernandez, *Shoe*. Markers, 6″ × 8″. Courtesy of the artist.

Patterns and dots contained in simplified shapes are characteristic of the work of artist Lenny Katz. Rich colors are achieved by contrasting overlays of color. These add an exciting dimension to works sometimes referred to as "drawn paintings." Try making a series of drawings using colored markers. Draw plant forms on non-traditional surfaces. Draw on wood, fabric and plastic as well as smooth, shiny and rough papers. Try coloring the edge of a piece of Styrofoam, using it as an eraser stamp and applying the design on areas of your drawing.
Lenny Katz, *Autumn Road Through Aspens*. Felt-tip pen on paper. Courtesy of the artist.

The inks used in markers today are spirit based and do not "bleed," or flow uncontrollably, as did the older inks. Most of the fine-line markers will smudge slightly before drying, and their colors will fade if exposed to strong light over a period of time. Inks are manufactured in many qualities, including permanent, water soluble, opaque, fluorescent and oil based. The latter can be used on almost any surface.

Markers can be rubbed and worked with other inks, and it is possible to obtain unique colors by working one color over another, as with water-color. They combine well with a host of other dry, moist and liquid media. Markers can be used with a variety of papers, including toned and pastel papers, layout and plain bond, bristol board, rice paper, watercolor paper, vellum and tracing paper, as well as a host of synthetic plastic surfaces.

This oversized, felt-tip marker has a beveled, wide tip. It can produce broad areas of value and line variation. Felt-tips are responsive to pressure changes that affect the quality of line. Today there are several hundred different colors of markers manufactured, as well as different styles of points.

Fiber tips are used to best advantage on coated papers or thick-coated cardboard. Fiber tip inks are chemically compatible with other media. Markers can produce solid areas of color using the side of the point, dots and dashes using the tip; overlays, by applying layers of color over one another; and line using the point, and by rolling the marker from side to side as you draw. How many different techniques can you identify in this self-portrait?

Alfredo deBatuc, *Self-Portrait with Sketchbook*. Felt-tip marker, 8½" × 11". Courtesy of the artist.

The artist who made this drawing was interested in expressing the force and power of the angry, charging wild boar. Rapidly drawn, short, abrupt lines oppose each other, and reinforce the portrayal of the animal's mood. The artist was not deliberate, nor was he concerned about proportion, detail or accuracy. This is a little unusual for a drawing done four hundred and fifty years ago. The bottom drawing, made after studying the top one, was drawn more accurately and deliberately, after the artist established the direction the work was to take.

Perino del Vega, Titian (Tiziano Vecellio), *Study of a Boar and Separate Study of its Head.* Pen and brown ink. National Gallery of Canada, Ottawa.

10

INK

Ink is one of the oldest drawing media known to human kind, having originated with the Chinese and Egyptian civilizations approximately 4,500 years ago. Colored inks were developed about 3,000 years later, also by the Chinese.

Originally, ink was made with soot, lampblack, burnt resins, or the burnt pits of cherries or peaches. The word *ink* comes from the Greek "encausticum" (to burn in). This described the acidic action of Greek ink which actually ate the paper.

In early inks, the carbon material was ground and mixed with gums, resins or glues. The mixture was dried and hardened until it was ready for shaping into stick form. The sticks or cakes could be liquefied, or dipped into water, and used in a semi-moist state. Past civilizations have used many implements, including reeds, thorns, quills and brushes for drawing with ink. These were dampened, and rubbed into the ink, then applied

to a variety of surfaces. Drawing surfaces have included papyrus, leather, linen, vellum, parchment, pottery, clay, bone and ivory.

Today, one of the most popular drawing inks is Indian ink. The name is misleading, since Indian ink was developed in China. It is the most permanent of inks, manufactured from a mixture of lampblack-carbon and gum.

Ink is a significant medium for contemporary artists. They may apply it with traditional metal nibs or with many non-traditional drawing implements including sticks, straws, ceramic tools, fingers, cloth, sponges, twigs, and spattering implements.

Ink requires attention from beginning artists. Their initial efforts may be awkward and clumsy. Ink demands control, speed, and confidence, yet its versatility permits the development of distinct, personal styles of expression.

Ink can be used with a wide variety of dry, moist and wet media. Dry media all produce different lines, values, and textures, and all share abrasive qualities. They must be prodded, pushed and pulled to produce their unique marks on drawing surfaces. The wet media, including ink, are not abrasive, however. They do not resist drawing gestures, as do dry media. As a result, the fluid media are harder to control. They flow, run, and drip easily, are receptive to air, are absorbed into drawing surfaces, and need time to dry.

Ink, as a member of the fluid family of media, requires skill and confidence. Ink calls upon the ability to readily accept your work despite the apparent lack of control. Unlike the more controllable dry media, which allow you to change your mind at various stages of a drawing, ink has bold, more committed qualities which do not permit the luxury of delayed decisions. With ink, artists learn to be spontaneous as they make their marks. Practice will increase your abilities and your appreciation of ink's less predictable style.

This pen and ink drawing was done with pen and brown ink by an unknown artist who used two different nibs. The drawing was done in different stages. A regular point, similar to a writing nib, was used for the darker values. These suggest depth. A narrow nib was used to describe the lighter and nearer forms. Cross-hatching was the principle technique used for the hands, whereas wavy lines were used for the other forms. Try filling a sketchbook page with different ink lines using a traditional drawing pen.
Anonymous, *Study of Ten Hands*, ca. 1680. Pen and brown ink, 7⅞″ × 12⅛″. National Gallery of Canada, Ottawa.

Traditional pen holders can accommodate a variety of metal nibs. For additional line variation, contrasting nibs can be taped to the handles of holders. Other drawing implements can be found, made or purchased. Aim for good balance of the implement in your hand during the act of drawing. You might try drawing with balsa wood sticks, dessert sticks, applicators, sharpened reeds, match sticks, twigs, feathers, brushes and wooden ceramic sticks to name a few. Select drawing tools that have contrasting tips, those that can produce thick and thin lines, interesting textures, and hard and soft marks on the drawing surface.

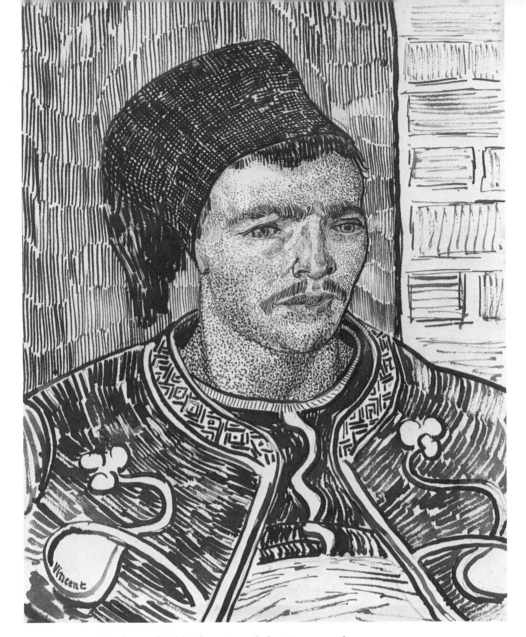

Vincent Van Gogh made this drawing of the Zouave officer Milliet, whose accounts of Indo-China inspired him as well as other artists. Van Gogh relied on the inventive use of a reed pen to produce distinctive lines, textures and patterns that are not confusing or chaotic. Vertical lines drawn close together suggest space by their value. They contrast with the cross-hatching seen in the cap, and with the dot pattern used to describe the face. How many different lines and textures did the artist use on the jacket and shirt? Try using a sharpened reed or stick to reproduce this drawing.
Vincent Van Gogh, *The Zouave,* 1888. Ink and reed pen, 9½″ × 12⅝″. Solomon R. Guggenheim Museum, New York, Justin K. Thannhauser Collection.

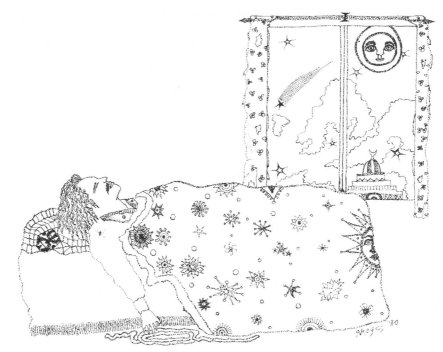

This very symbolic drawing was done with a traditional pen holder and a regular nib. The entire drawing is comprised of dots that achieve an illusion of depth and dimension by overlapping and rotation of line. Value was used in a limited way, primarily as a decorative element, not to describe the roundness of form. Try making a drawing using dots only, using a small, pointed stick or the end of a flat pencil eraser used as a stamp.
Ricardo Reyes, *The Dreamers*. Ink, 8½" × 11". Courtesy of the artist.

This drawing was done using a fine crow-quill pen that produced narrow, delicate lines, suited to the technique of cross-hatching. On this drawing, the lines were placed close together, producing subtle values and accurate modeling of the form. Alter a piece of fruit or vegetable, such as an apple or pepper. Use cross-hatching to draw the removed section as well as the major form itself. This exercise will aid you in understanding cross-hatching, form and value.
Lissy Kuhn, *Apple with Section Removed*. Ink,
6" × 8". Courtesy of the artist.

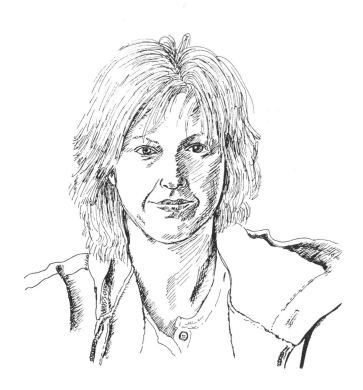

For many years, artists have borrowed ideas about media and the use of drawing tools. Artists who draw can learn from other artists, such as architects, illustrators and designers. This drawing was done in a traditional pen and ink manner, with a drawing pen. This pen design replaced the ruling pen, used originally for drafting. The newer drawing pens generally have a hollow body for the ink supply, as well as several replacement points. The principle advantage to this kind of pen is the consistent flow of ink. As such it has the potential to create numerous uninterrupted drawings.

Alfredo deBautuc, Jan. Ink and rapidograph pen, 8½" × 11". Courtesy of the artist.

6x0	4x0	3x0	00	0	1	2	2½	3	3½	4	6	7
.13	.18	.25	.30	.35	.50	.60	.70	.80	1.00	1.20	1.40	2.00
.005 in.	.007 in.	.010 in.	.012 in.	.014 in.	.020 in.	.024 in.	.028 in.	.031 in.	.039 in.	.047 in.	.055 in.	.079 in.
.13 mm	.18 mm	.25 mm	.30 mm	.35 mm	.50 mm	.60 mm	.70 mm	.80 mm	1.00 mm	1.20 mm	1.40 mm	2.00 mm

Ever since artists began drawing, a drawing implement with an ink reservoir has been desirable. With a continuous flow of ink, the constant interruption of the drawing process is no longer necessary. Interchangeable nibs now make it possible to produce a variety of drawing marks as well.

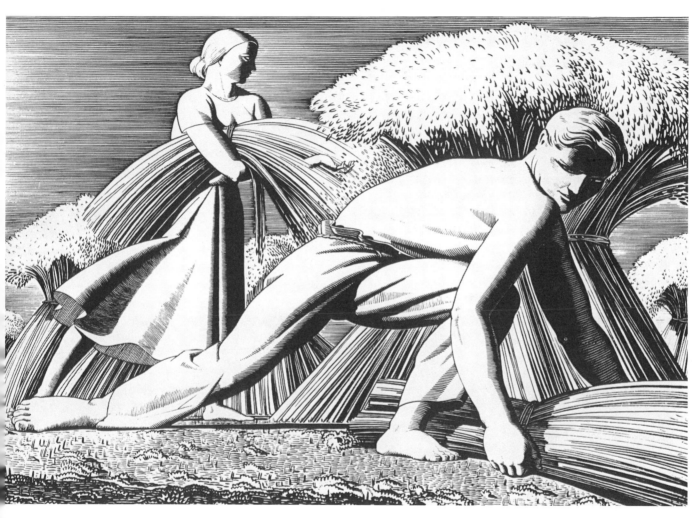

This unusual pen and ink drawing appears almost mechanically drawn. The artist used brush and ink to strengthen the initial pencil sketch, giving the image a wood-cut appearance. The artist established a powerful feeling and a harsh mood through extreme contrast of line and value. The emphasis on emotional feeling in artworks is characteristic of Romanticism, developed in the 18th century. There is very little variation of line, yet there is sufficient interest in the artist's style and ample evidence of his skill as an artist.
Rockwell Kent, *Harvesters*. Ink and pen. One Art Service, New York.

This drawing was done with a thin, round stick, held in the middle and near the end to gain or relinquish control over the image. A slow, investigating gesture was used, attempting to keep the line continuous while looking at the form. The artist stopped only to replenish the ink. Experiment with applicator sticks as drawing implements. Break them to produce a variety of tips. This will enable you to produce various line qualities.

Virginia Paleno, *Portrait*. Ink and stick on tan paper, 6″ × 8″. Courtesy of the artist.

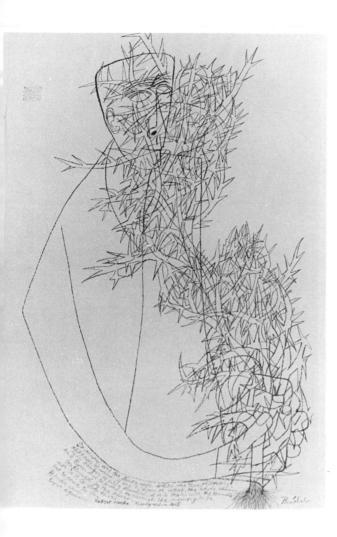

The word "penna" comes from the Italian word for feather. This is the origin of the word "pen." Ben Shahn made many of his drawings with pen and ink, or with sticks. When held vertically, on the point, a pen or stick will skip across the drawing surface, leaving an interesting textured line. You can study the results on areas of this drawing. Try dipping a pen, match stick or applicator stick in ink. Produce textures that you can use in your drawings.

Ben Shahn, *The Blind Botanist*. Ink on paper, 38½" × 25¼". Minnesota Museum of Art.

Alexander Calder experimented with creating small movable sculptures and thin wire sculptures of circus images. His ink drawings are reminiscent of a continuous piece of formed wire. The drawings look almost as if the background paper has been cut away, leaving only the lines. The lines have few thick or thin variations, and reinforce the flatness of the drawing surface.
Alexander Calder, *The Catch II*, 1932. Pen and ink, 19⅛" × 14⅛". The Museum of Modern Art, New York, gift of Mr. and Mrs. Peter A. Rubel.

The subject for a drawing can be something that you are totally familiar with.
American artist Edward Hopper drew his studio. He simplified the drawing by
using elementary linear drawing techniques. In this ink drawing, you can study
the differences between lines that were rotated and parallel lines. Notice the
way forms were made to appear flat, advance or recede. The artist separated
forms from one another using value and line. For an example, study the upper
right part of the composition.

Edward Hopper, *Artist's Studio*, ca. 1900. Ink and pencil on paper,
14½″ × 11⅜″. Whitney Museum of American Art, New York.

This drawing was initiated with a small, round stick dipped in water and quickly applied with repeated gestures. This saturated the drawing surface, preventing the rapid evaporation and absorption of the thin lines of water. Unmixed ink was then applied to the water lines using the stick. Capillary action pulled the ink along the thin paths of the previously drawn areas, making the line visible. The final stages included drawing the small insect on dry paper and over the fresh ink lines as they began drying.

Joseph Mugnaini, *Insects*. Ink, water, stick and pen, 8½″ × 10½″.

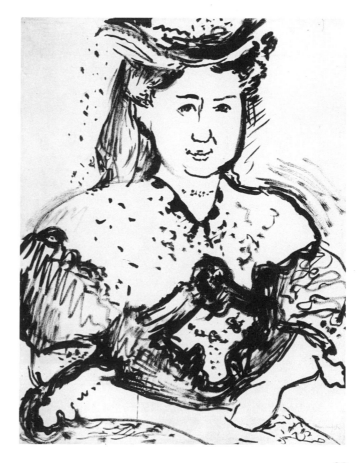

This portrait was made by French artist Henri Matisse. He used a brush, reed pen and ink. Reed pens do not hold vast amounts of ink. They produce a dry, textured line as the ink is exhausted. On this drawing, the marks made by the reed pen contrast with the thick and thin lines made with the soft hairs of a watercolor brush loaded with ink. The consistent flow and appearance of ink lines can be varied by using the brush on its tip, or by using pushing and pulling motions. These can produce thick and thin lines. Try making a reed pen from a piece of dried bamboo. Sharpen both ends differently to produce a tool for variation of line. Henri Matisse, *Jeanne Manguin*, ca. 1905–06. Brush, reed pen and ink, 24½″ × 18½″. The Museum of Modern Art, New York, given anonymously.

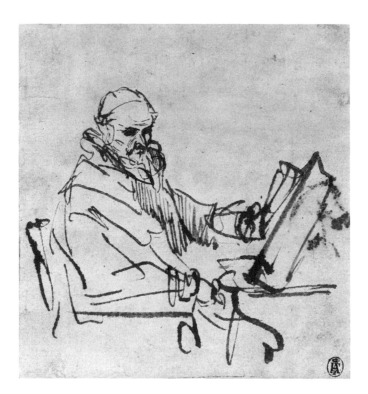

For this drawing, Rembrandt used reed pens made from wood and quill pens made from feathers. Tools o. this sort were used by many ancient artists. Reed pens can produce a dry, textured line because some of the ink is absorbed in the wood of the pen, as well as released on the drawing surface. The lines differ considerably from those made by quill pens. The point of a quill does not absorb ink as readily, so it produces a "wetter" looking line. Quill pens are light, so they do not offer resistance. This leaves you more aware of your hand during the act of drawing.

Rembrandt Van Rijn, *Jan Cornelis, Preacher.* Reed, quill and ink. National Gallery of Art, Washington, D.C., Rosenwald Collection.

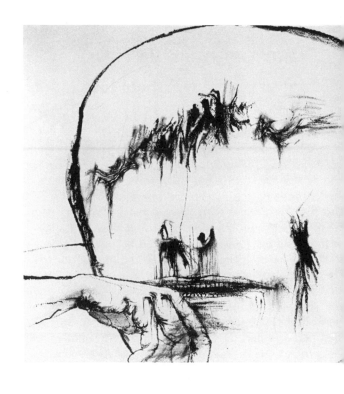

One of the most driving forces in modern art is its expressive qualities. Artist Leonard Baskin began this emotional drawing with preliminary pencil lines, followed by ink applied with a brush. The darker values were produced with a loaded brush and ink; the textures, and light values with a dry brush, dragged over moist ink. The crisp lines were produced with pen and ink.

Leonard Baskin, *Weeping Man,* 1956. Ink and pencil on paper, 22½" × 31³⁄₁₆". Worcester Art Museum, Worcester, Massachusetts.

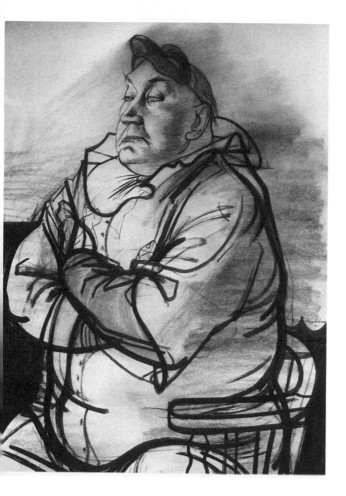

Ink can be used with many chemically compatible media. In this drawing, red and black chalk were used to explore the form and partially model it. The chalks contrast with the paper, which shows through. They also contrast with the ink lines drawn over them. A watercolor brush loaded with ink reinforces the chalk underdrawing and gives visual weight to the form. Additional variation and interest were achieved by contrasting straight, curved and angular lines. Ink was also used to describe the space behind the figure.

Rico Lebrun, *Seated Clown*, 1941. Ink, wash, chalk, 39½″ × 29″. The Santa Barbara Museum of Art, Santa Barbara, California, gift of Mr. and Mrs. Arthur B. Sachs.

English artist Aubrey Beardsley was influenced by the decorative arts of 19th-century Japan, and the 5th-century Greek vases that he studied in the British Museum. As a representative of the Art Nouveau movement, he influenced many modern artists, including Picasso. His drawings were done in precise, firm outlines without traditional modeling. Beardsley's work is very decorative in style, often with intricate patterns of natural shapes. This drawing was done as an illustration for a play written by Oscar Wilde.

Aubrey Beardsley, *Salome*. Ink with green watercolor wash, 11″ × 5¹³⁄₁₆″. Princeton University Library, Princeton, New Jersey.

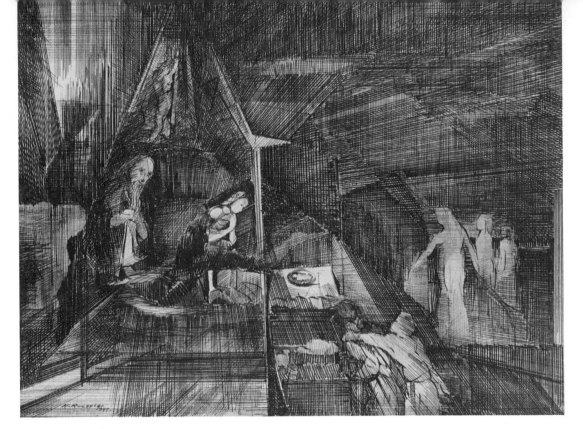

Herman Roessler, *Nativity with Shepherds*. Pen and colored inks on buff paper. 11½″ × 14⁹⁄₁₆″. Courtesy Museum of Fine Arts, Boston.

Some artists have the ability to get to the essence of a form with an economy of line. This is in direct contrast to the continuous, exploratory line used by some other artists. This drawing was done with a slow, deliberate line that appears continuous. Line unifies the drawing, and captures the unique characteristics of the subject matter.

Henri Matisse, *Portrait of Louis Aragon's Wife*. Pen and ink, 18¼″ × 11¼″. Courtesy Mekler Gallery, Los Angeles.

The brush is one of the artist's most expressive implements for ink drawing. It can be held close to the tip for control, or held far back on the handle for more expressive drawing. Brushes can produce bold, delicate or fine lines, texture and value. They can be loaded with ink and used wet, or used partially loaded to achieve a dry brush technique. Rembrandt incorporated several techniques in this drawing. Select a good watercolor brush and fill an entire drawing surface with marks made with a brush and ink. Try making each mark different.

Rembrandt Van Rijn, *Sleeping Woman*, ca. 1650. Brush and ink, 9¹¹/₁₆" × 8⅛".
The British Museum, London.

Anna Rodrigue

11

WASHES

Artists have traditionally used more than one medium to communicate ideas about things seen or felt. Some media are more suited for accurate representation, while others are best suited for expressive work.

Wash drawings are somewhere between drawing and painting. They are well suited to expression because both the drawing implement and the fluid can be used in many ways. This medium encourages a fluid play of lines, values and textures. Wash is simply pigment that has been thinned with a solvent. The dilution process makes it possible for artists to produce value gradations with washes.

Washes usually are ink or watercolor thinned with water. Sometimes washes are made with tempera, acrylics or gouache, thinned with water,

or made with oil pigments thinned with turpentine. It is possible to make washes with a wide range of dry media including charcoal, conte, chalk and pastels, thinned with water, and crayons or oil pastels, dissolved or thinned with turpentine.

Washes can be applied directly to the drawing surface with brushes, rags, sponges, paper towels and sticks. Balsa wood works well because the wood absorbs some of the liquid medium, producing a wet to dry mark on the surface. Washes can be applied before or after other media when used in combinations.

As with other drawing media, washes require contrast. Ink, for example, relies on the contrast between the white of the paper and the black of the ink. Washes, however, have a wide range of

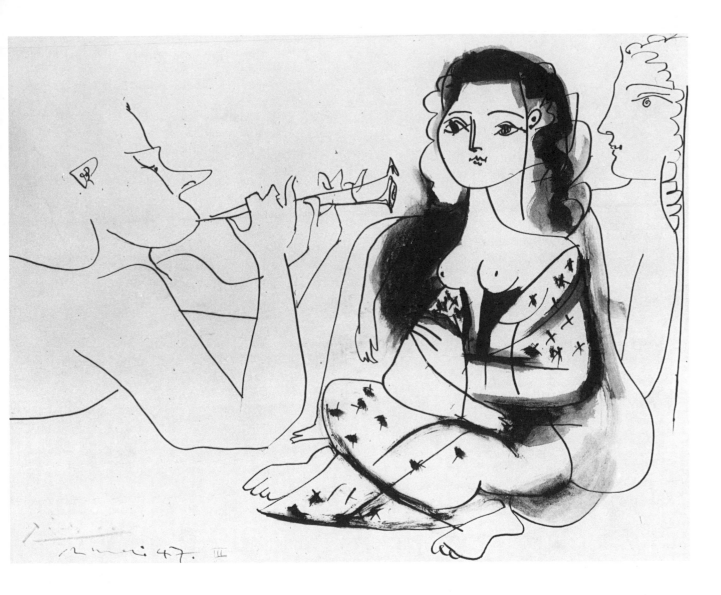

Pablo Picasso selected a drawing implement that produced a consistent line with little thick and thin variation. The line quality and the absence of traditional modeling enabled the artist to preserve the flatness of the picture plane. This is a component of Cubism. The artist's intent was the division of space, using line. A dark wash helps describe the hair, arm and space on the left side of the central figure.
Pablo Picasso, *Joueur de Flute et Deux Femmes Assises Par Terre*. Ink, wash, 49.5 × 65 cm. Courtesy Mekler Gallery, Los Angeles.

grays. Thus washes depend on the artist's technical skill and effective use of the white of the paper to produce value contrast. To lighten wash already on paper, use a clean, wet brush on wet areas. Before you finish, step back and see that there is enough contrast to communicate your ideas.

Washes can be used with many other media, such as colored inks, charcoal, conte, chalk, ballpoint and acrylics. Experiment with wash alone, and then try using it before and after other drawing media.

A medium gray wash applied with a moist brush was used to begin this drawing. The brush was held close to the tip while the artist pushed down on the hairs with considerable force. This results in a textured surface from the wet, loosened fibers of the paper. A smooth bond wrapping paper was used, so a dry brush effect was not achieved. A pen and ink line was used for the descriptive embroidery of the bullfighter's jacket.

Bob Blivens, *Matador*. Wash, pen and ink on white paper, 16" × 30".

This abstract drawing was made with a painting trim brush, similar to the type that can be purchased at a hardware store. The two-inch wide brush was used with small amounts of ink on textured paper to produce a dry brush effect. By pushing and pulling on the brush during the act of drawing, the artist was able to produce value variation. The initial expressive drawing was followed by pen and ink line on selected areas, bringing forms into focus.

Joseph Mugnaini, *Figure*. Wash, ink, brush and pen, 18" × 24".

Unmixed ink was used to describe the clothing and hat of an aged musician. A watercolor brush with the hairs spread out to resemble a star, with small amounts of ink, produced the dry-brush patterns of the costume. The drawing brush was used as a stamp to print the designs on the drawing surface, and a deliberate line was used to describe the age and dignity of the face. Tina Lee, *Cleo*. Wash and line, 24″ × 30″. Courtesy of the artist.

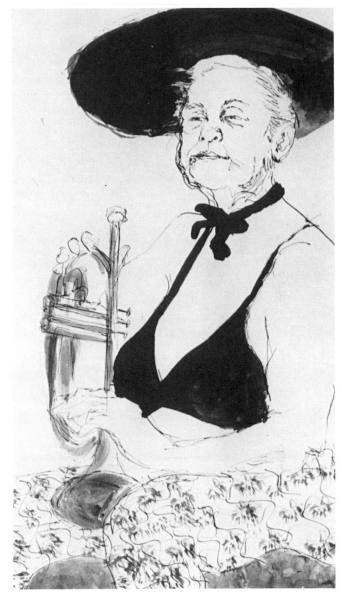

A drawing with limited watercolor washes might look like this. The initial stage of this drawing was done with pen and ink. Areas of the paper and some of the lines were wet with water and applied with a clean brush. Waterproof drawing ink did not mix completely with the water. This resulted in interesting line variation on the neck, nose and chin. Watercolor washes, however, are readily absorbed and mix freely with the clear water. Cathy Curl, *Portrait*. Watercolor and ink, 18″ × 24″. Courtesy of the artist.

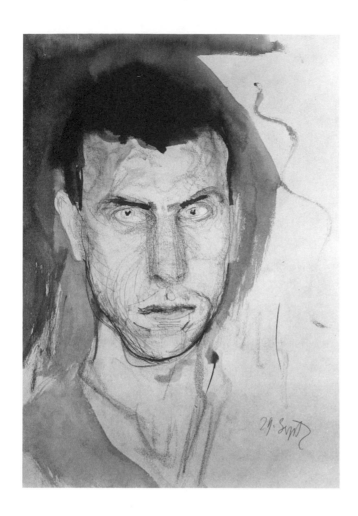

Artist Richard Gerstl made preliminary drawing marks with pencil and conte. A gray wash was drawn around the area that made up the face, ear and neck, and the area in front of the left shoulder. Notice that the background actually merges with the foreground. While the paper was still wet, the artist brushed unmixed ink on the drawing, producing the inadvertent results seen at the top of the drawing. The artist created a strong composition by positioning the face off center. Additional interest was achieved with the crisp, delicate ink lines drawn on a dry surface.

Richard Gerstl, *Self-Portrait*, 1908. Wash, 15¾" × 11¾". Copyright 1974, Galerie St. Etienne.

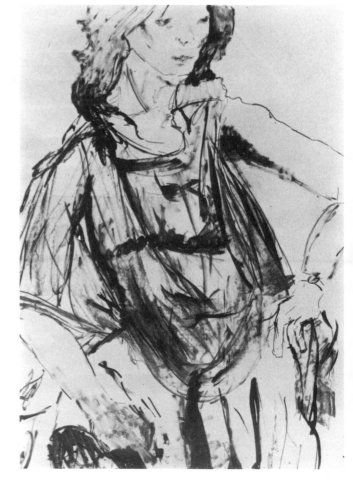

Ink and watercolor washes were the principle media used on this drawing. A large watercolor brush, with blue watercolor paint, was drybrushed over the surface to explore the form. This was followed by dry and wet-brushed ink. A good watercolor brush will come to a point when wet. A similar brush was used to draw the more critical lines that help describe the form.

Shawna Leavell, *Self-Portrait*. Ink, watercolor, wash and brush, 18" × 24". Courtesy of the artist.

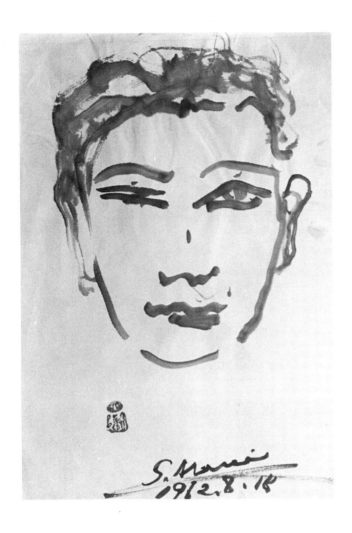

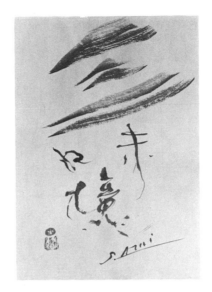

Unmixed ink can be used as a wash and wash can be used as line. This portrait drawing was made by a Japanese artist using a special brush and sumi ink. The ink is made into stick form and is ground in a dish or block. Depending on the amount of water used, the medium can be employed as an ink or a wash. The same artist made the landscape drawing holding the brush between his teeth. Both techniques demonstrate the potential of wash as line, texture and value.
Seigi Asuri, *Portrait, Landscape*, 1962. Wash, brush and sumi ink, 9" × 11".

This powerful drawing relies on the visual impact that results when ink wash is applied over white paper. An illusion of deep space is established on the picture plane. The ink moves from the background to the foreground and into the fabric folds of the figure. A sharpened twig, with a diagonal cut, was used to draw the line into both the wet and dry areas of the drawing. The artist held the twig far back from the tip to achieve more interesting line quality by relinquishing some control over the drawing tool.
Jody Samuelson, *Cleopatra*. Wash, ink and twig, 22" × 30". Courtesy of the artist.

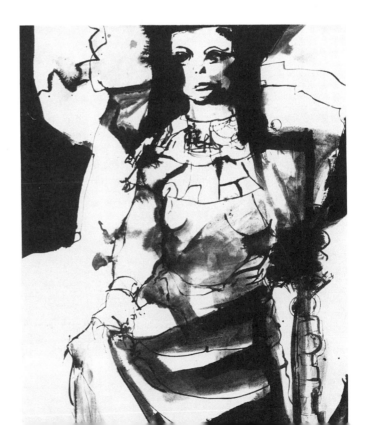

Wash drawings can be used as an introduction to
painting. Often they serve as preliminary studies for
water media paintings. This wash drawing effectively
demonstrates the control possible with fluid media.
These values, lines and textures are possible with a
medium normally associated with fluidity, spontaneity
and flowing shapes. Make a drawing using a water-
color brush only, and make one with a bristle brush.
Compare the results.

Maryrose Mendoza, *Hand, Brush, and Leg.* Wash and
brush, 18" × 24". Courtesy of the artist.

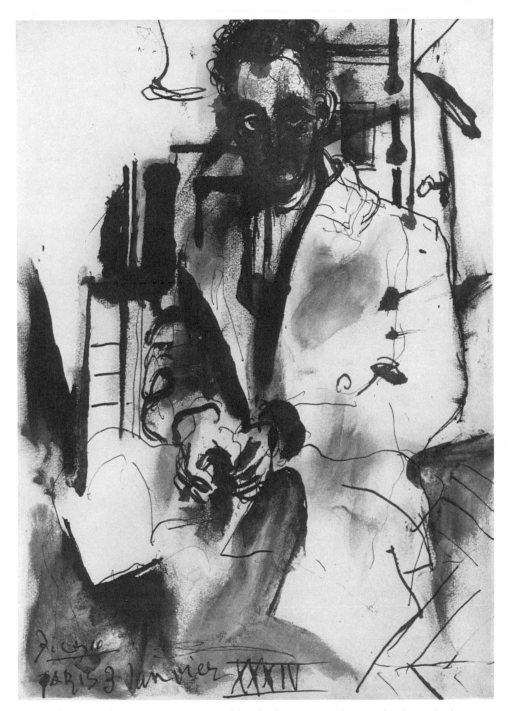

Artist/photographer Man Ray was a friend of Picasso, who made this ink draw-
ing. Study the left side and lower center of the drawing to see how Picasso
made a preliminary dry-brush drawing that defined the face, left shoulder, arm
and coat. The artist used the same technique on the right side to define the
room's interior. Unmixed ink was then drawn over some of the areas of dry-
brush drawing, followed by thick and thin contour line. The dry-brush technique
can also be seen in the paper's texture.
Pablo Picasso, *Portrait of Man Ray*, 1934. India ink, 13⅝″ × 9¾″. Collection
Paul Kantor, Beverly Hills, California.

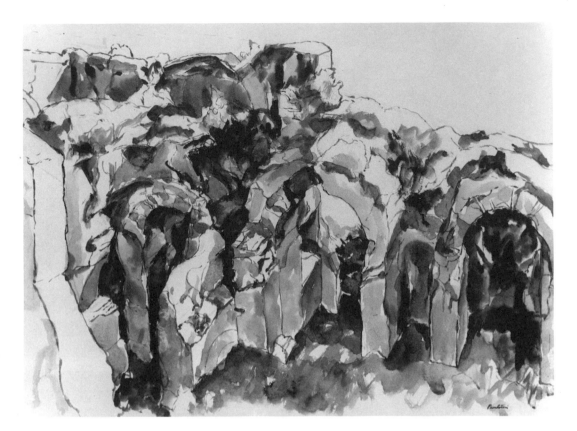

Drawing defies a single definition and now includes
most works on paper, even though more color is being
used and painterly techniques continue to be em-
ployed by many artists who create drawings. This
drawing was done as a study for a painting of the
Palatine ruins in Rome, and was created with tech-
niques familiar to water media painters. Wash and line
portray the arches set in shallow space. Light is
described by varying densities of wash and with the
white of the paper allowed to remain undisturbed.
Philip Pearlstein, *Palatine #14*, 1959. Wash on paper.
Courtesy the Allan Fromkin Gallery.

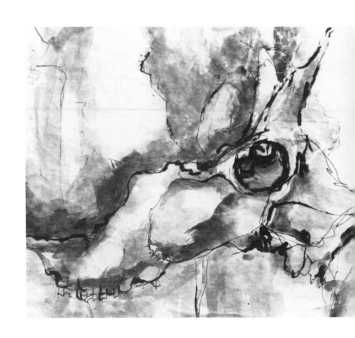

Wash drawings gain greater significance when painterly
results are sought. Clear water was applied with a
clean brush to white paper, starting with the back-
ground shapes and progressing to the foreground. The
artist worked quickly to avoid having the water dry by
evaporation and absorption. Gray washes were then
dripped into the wet areas and allowed to flow, helped
along by tilting the drawing board. As both water and
wash dried, pen and stick lines were drawn to clarify
the form and to separate similar values.
Jane Berman, *Animal Skull*. Wash, water and ink,
28″ × 30″.

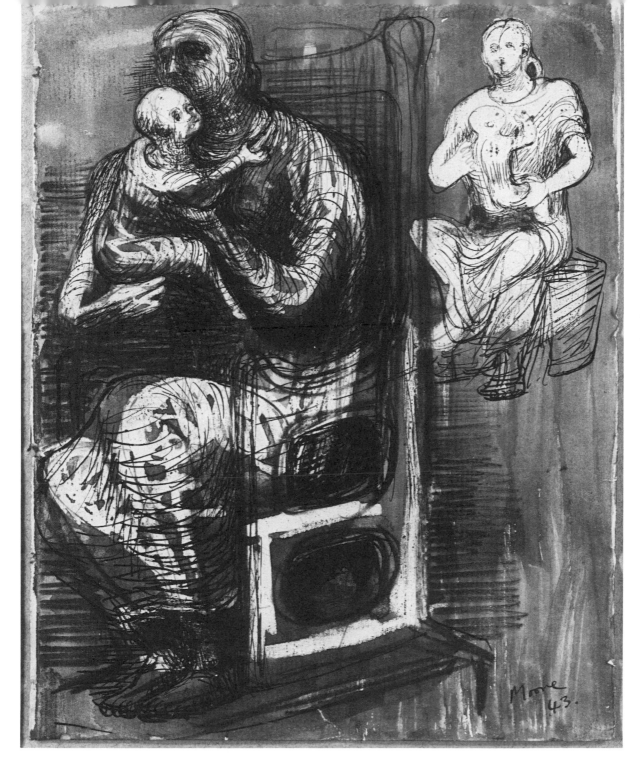

English artist Henry Moore made this wax resist drawing. Wax crayons, large candles, paraffin wax (used for canning) and oil pastels are water resistant. Interesting, often accidental results are made visible by ink and wash overlays. The artist drew first with a light-colored wax, followed by light washes, pencil, dark washes, and finally pen and ink. Pencil was used to define form as a sculptor would, carving large areas of stone. Pen and ink were used to describe form and volume.

Henry Moore, *Madonna and Child*. Crayon, wash, pencil, pen and ink, 8⅞″ × 6⅞″. The Cleveland Museum of Art, Cleveland, Ohio.

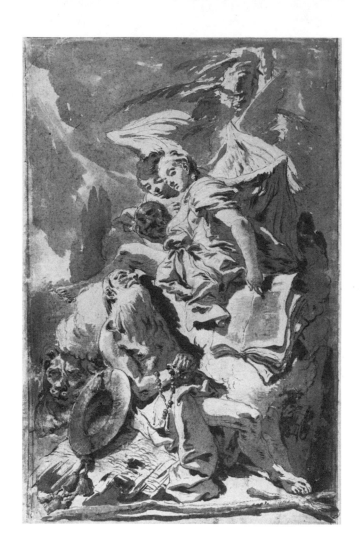

Giovanni Tiepolo was the greatest fresco painter of the 18th century. He used red, black and white chalk, as well as wash on many of his drawings. He used primarily colored papers, and almost all of his drawings were done as preparations for his paintings. Few artists could compare with his ability to render light with pen and wash. On this drawing, the untouched paper was heightened with Chinese white and appears to be in full sunlight, while the washes appear to be covered by cool, transparent shadows. The drawing was done in several stages, with pen and ink used to begin the drawing.

Giovanni Battista Tiepolo, *St. Gerome in the Desert Listening to the Angels,* ca. 1730. Pen and brown ink wash, heightened with black chalk on buff paper, 16¾″ × 10⅞″. The Armand Hammer Foundation, Los Angeles, California.

This drawing was done in several stages. The first stage was a light gray wash. It defined shallow space, established the area that the two figures were to occupy, created additional shapes on the picture plane, and preserved the white of the paper. Next a medium gray and a dark gray wash were used one after the other and after drying. These redefined the shapes of the figures. The shapes are more pronounced on the upper and lower right and on the left of the drawing. During the wash stages, the artist defined form with wash and ink lines drawn with a stick or pen.

Rico Lebrun, *Figures in the Flood,* 1960. Wash and ink, 10″ × 13″.

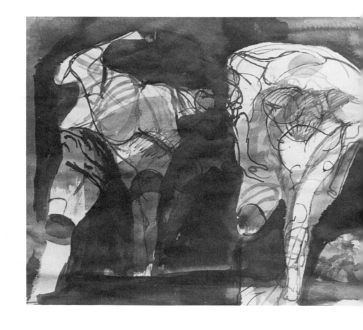

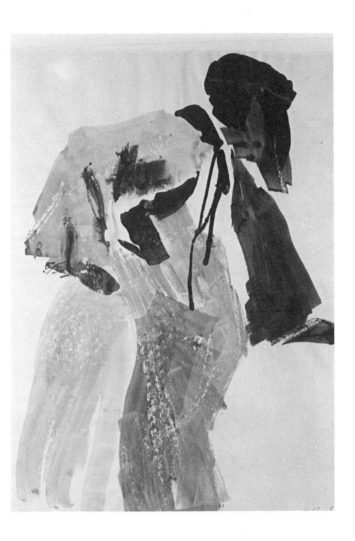

Medium and dark washes were applied with a rag, small cardboard squares, and a flat watercolor brush. The collar of the garment was drawn with a brush, the ink running down the slanted drawing surface. Accidental results often add interest to a drawing and reinforce the fluidity of the medium. Make a pen and ink drawing using waterproof ink, and allow it to dry. Soak the drawing surface with a sponge and water, or immerse it in water for a few minutes. Sprinkle finely-crushed charcoal dust on the wet surface and allow it to dry. This can add another dimension to your work. Jackie Cioffi, *Figure.* Wash and ink, 18" × 24".

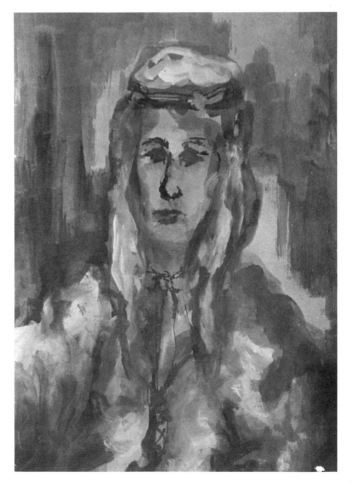

Many of the drawing masters of the Renaissance believed it more beneficial for young artists to begin their training with dry media, progressing to fluid media only after a prescribed period of study. They felt that since ink and wash could not be erased, both media required a more masterly hand. This drawing was made more difficult when the artist wet the paper before applying the wet media. The technique contributed to the spontaneity of the drawing. It is difficult to control fluid media applied to a wet surface. As suggested by Renaissance artists, more skill and confidence are necessary.
Scott Tolme, *Portrait.* Wash, 22" × 30".

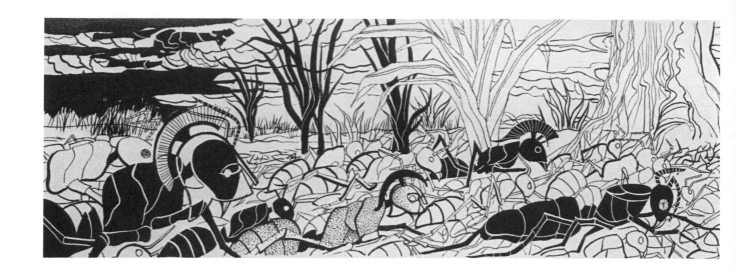

12

GOUACHE AND OIL PIGMENTS

Gouache

Until watercolor paint was developed to perfection by 17th-century English painters, gouache was preferred. Up to that time, gouache colors were the only finely ground pigments available to artists. Finely ground watercolor pigments do not settle out when in suspension. They become part of the surface. This is more noticeable when attempts are made to wash off the color. With watercolor, some colors will remain on the paper, even though fainter than they were when applied.

Gouache is sometimes called designers colors. Actually, gouache is watercolor paint that has Chinese (zinc) white pigment added. This makes the color opaque. Occasionally gouache is made in two steps, with the paper coated in white pigment and the transparent watercolor floated on the surface. The white of the paper is changed by the white gouache ground, and thus the medium is changed from watercolor to gouache, and from transparent to opaque. Because gouache is opaque, it works well on toned papers. This can add another dimension to your work.

Gouache is manufactured in tube or pan form. In full strength, the colors are strong. When thinned with water, they become dull and clouded. Gouache can be used with other dry, moist and liquid media.

Gouache is a medium suited for painting, drawing and design. The gum binding agent, however, does not bind thick layers of pigment to the surface, and for this reason, artists use gouache for its opaque qualities. These permit changes in the work without thick coatings of pigment. Because drawings tend to be worked on for shorter periods than paintings, excessive pigment build-up is not necessary, nor desired. Joseph Mugnaini used ink and gouache to make the flat shapes, plants and army ants that here assume surreal features.
Joseph Mugnaini, *The Myrmidons.* Gouache and ink, 3″ × 9″.

This drawing by Nancy Graves was done using opaque pigments. The drawing consists of thousands of different colored dots, applied with irregular shaped drawing implements. They were used to stamp the paint on the surface of the paper. An illusion of shallow space was achieved by placing light colored dots next to dark ones. When you half squint your eyes, you can see swirling patterns similar to the ones that greeted our space explorers. Try putting a magnifying glass on a colored magazine photograph, to gain an understanding of how dots can create an image. Look at the drawing by Van Gogh on page 82 and then study the work of the Pointillist painters.
Nancy Graves, *Mariner IV, Mars Red Filter.* Gouache, 22½″ × 30″. Courtesy of the artist.

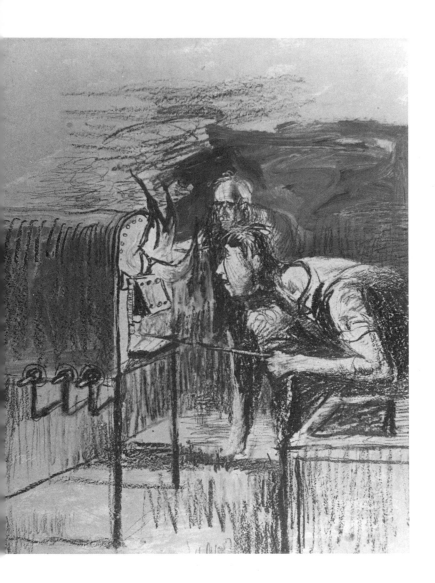

Graham Sutherland was a prolific artist who was appointed England's official war artist during World War II. His work reflects his training as a painter, his deep commitment to his country, and the emotional involvement he experienced during a dark period of English history. Many of his war drawings were created using different hues of gouache and colored chalks. When combined, these produced the rich colors prevalent in his work. Several drawings were made in bomb shelters, coal mines, and caves. This drawing combines gouache, chalk, pencil and pen and ink.

Graham Sutherland, *Two Men Looking into Furnace*, 1944. Gouache, pencil, pen and ink. City Art Gallery, Bradford, England. © COSMOPRESS, Geneva, ADAGP, Paris.

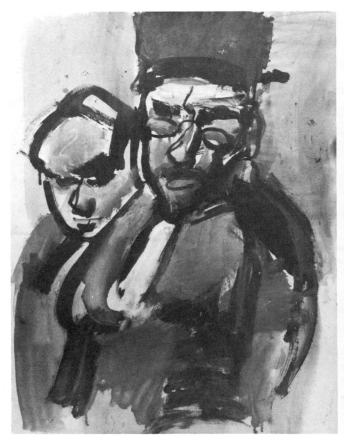

All media, be they wet, moist or dry, require time and practice to comprehend and control them. Often it is helpful to see how other artists use a medium. On this drawing, Georges Rouault thinned dark gouache and used it as a wash. The value was dulled with the addition of water. A wide bristle brush, loaded with unmixed gouache, was drawn over the wash, defining the forms and separating the similar values of the background from the foreground.

Georges Rouault, *The Judges*. Gouache on paper, 25⅛″ × 18¾″. Portland Art Museum.

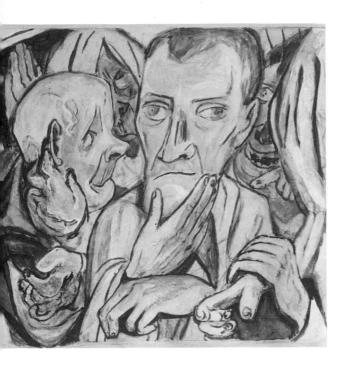

Max Beckman was a German Expressionist artist who at one time was strongly influenced by 15th-century woodcuts that had religious themes. This gouache drawing was done on the back side of an illuminated Bible page. Note the flat application of light-colored opaque paint. This makes the lines appear as though they were inscribed, dividing the drawing surface into organized shapes. The lack of contrast also contributes to the flatness of the shapes and the feeling of shallow space.

Max Beckman, *The Prodigal Son*, 1918. Gouache and watercolor with pencil underdrawing on parchment, 14½″ × 11¾″. The Museum of Modern Art, New York, purchase.

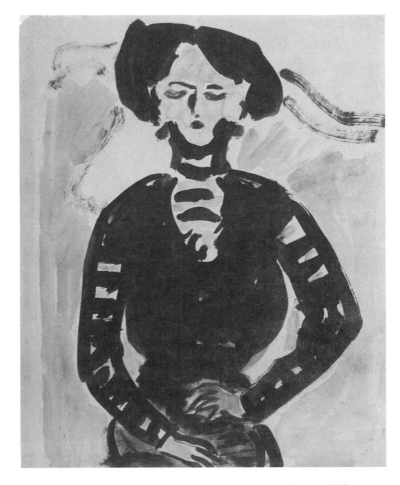

Gouache is manufactured in tube and cake form and is applied best with watercolor brushes or stiff bristle brushes. Often a medium suggests a technique or style. Every time you use a new implement or medium, experiment with them in various ways that interest you. On this drawing, a wide bristle brush was used for both wet and dry applications of pigment. The ease or difficulty of achieving variations in line, tone and texture is influenced by the artist's methods and by the medium and the implement used. These also influence style, image and personal manners of expression.

Ernst Kirchner, *Portrait of a Woman*, ca. 1907. Gouache, 17⅝″ × 14″. The National Gallery of Canada, Ottawa.

Richard Bunkall, *Cityscape*. Oil sketch with traces of charcoal, 4' × 5'. Courtesy of the artist.

Oils

Artists have used oil paints for hundreds of years. Oil paints are normally associated with painting, despite the large number of drawings executed with oil pigments. Sometimes it is difficult to say whether a work is a drawing or a painting. In any case, it is useful to remember that oil paint can be used for both.

Oil paint was used first in the 16th century, in combination with egg tempera paint. At that time artists discovered that oil-based pigments could be applied over water-based media.

Oil paints are made with various combinations of oils, resins and turpentine. Oils can be applied with stiff bristle brushes without use of a solvent, or by applying thin coatings of pigment, or by using a scrubbing technique to model form and describe tone and texture. With practice, the square tip of the bristle brush can be made to produce line. Dry-brushed oil paint works well underneath most dry media, Indian ink, wax crayons and oil pastels. Moist media, however, are not likely to combine well with oil paints, and wet media are not suggested.

Oil paints diluted with turpentine produce a thin, colored wash. This absorbs well into paper's fibers, tinting the surface. It provides a rich base for the application of other drawing media. Washes can be applied with bristle brushes, rags, sponges, paper towels and watercolor brushes. **Follow all safety precautions when using turpentine.**

Using thin washes made with oil pigments and turpentine, experiment on wet, moist and dry surfaces. Find out which other media are compatible with oil washes. Most dry media can be applied over oil washes, since they are chemically compatible with the solvent and the pigment binding agent.

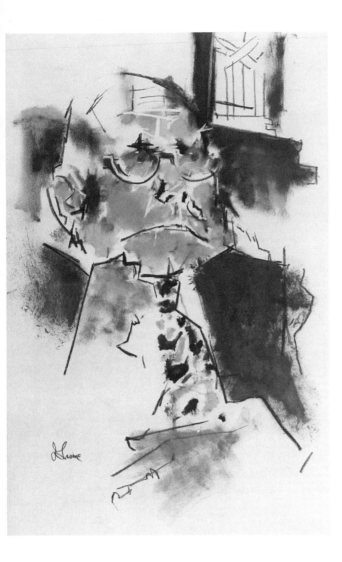

Artist Jack Levine used a stiff bristle brush to apply oil paint on this drawing. He started on the lower right of the composition with a large, flat shape, and gradually distributed the pigment over the surface to achieve visual balance. As the medium was exhausted, a dry-brush technique became more evident. Lines were drawn with pastels to define form and space. Oil pigments can be applied on rough or smooth surfaces, but when used for drawing, use them sparingly, or thinned with turpentine to cut down the drying time, and to increase the potential for combinations with other media.

Jack Levine, *Fashionable Necktie in a Courtroom*. Oil and pastel on paper, 39¾″ × 25½″. Courtesy Kennedy Gallery, New York.

American artist Charles White used thin oil washes on this drawing to establish basic shapes in the composition. A very fine pointed brush was used with slightly thicker washes to draw in the lines and to bring the forms into focus. The hand print and stencil lettering add symbolism to the drawing as well as elements of composition. The turpentine washes were used because of their rapid evaporation rate, allowing the artist to make decisions about the drawing without waiting for the linseed oil in the paints to dry.

Charles White, *Mississippi*, 1973. Oil on board, 60″ × 48″. Courtesy Heritage Gallery, Los Angeles.

13

WATERCOLOR

Closely related to wash drawings are works made with watercolor on paper. Watercolors could be all paints that have water as a medium, including tempera, gouache and scenic colors (sometimes called distemper). Today the term "watercolor" usually refers to pigments that have a gum arabic binder and are transparent.

There are differences between watercolor and wash drawings. Wash generally provides a monochrome effect which is very different from drawings in color. Wash and watercolor have different binding agents, too. In watercolor, the pigment binder is water soluble. This allows artists to

soak, blot or scrub down to the surface of a work, if necessary. Ink washes made with a waterproof binder are more difficult to change. The wash pigment is absorbed deep into the fibers of the surface and leaves a ghost image. With wash, changes can be made by adding line, to separate two similar values, or by applying a darker wash or unmixed ink, or by waiting for the drawing to dry, and then lightening some areas with a light pigment such as Chinese white.

Watercolors are manufactured in tube or cake form, and as liquid. The latter are actually made from dyes, and though the colors are intense, their

American artist Albert Porter used a block-out medium and watercolor washes for this drawing. The water resistant medium was drawn on the surface first and allowed to dry. Watercolor washes were then brushed on to describe form and space. The block out medium was then removed, creating interesting negative lines. Albert Porter, *Untitled* 1986. Frisket, watercolor and wash. Courtesy of the artist.

Oriental artists traditionally have used brushes for writing, drawing and painting. The close connection between the three art forms is one reason many beautiful ink, wash and watercolor drawings remain part of Oriental culture. This drawing was made using a wet-into-wet technique, where wash and watercolor were applied to a wet surface. The calligraphic lines of the animals were applied to a moist surface, resulting in their soft focus. The crisper lines were drawn on a dry surface and provide sufficient contrast. Maruyama Oju, *Two Bulls*. Watercolor and ink, 11½" × 12¾". The Minneapolis Institute of Arts.

Blue and black watercolor washes were used for this drawing. There was no attempt to keep the colors separated. Instead the artist allowed the colors to flow and mix to produce a third value. Some ink lines were stamped on the drawing with a small cardboard square, and others were drawn with a stick. Lynn Martin, *Chick*. Watercolor and ink, 12" × 18".

permanence is suspect. Unlike tube or cake water-color, however, the liquid can be used directly from the container with pens and other drawing implements as well as brushes to produce line and wash.

Tube watercolors are usually more expensive and have the addition of glycerin to keep them from drying in the tube. Probably the most common form of watercolor is the small cake or pan familiar to many of us.

Traditionally, artists have preferred to use certain colors in washes because of their compatibility with other drawing media, including inks, markers and dyes. The colors include blacks, browns, sepia and bistre, a type of brown. The earth reds have been popular with artists as well. Watercolor can be used before or after many dry, moist and wet media.

This watercolor drawing was done about ten years after the invention of photography, when representational images were still required and in demand. The artist made a drawing in one-point perspective, then accurately rendered the drawing with watercolor. Try making some drawings of architectural locations using watercolor, or watercolor and markers. Include one- or two-point perspective in your work.
John W. Hill, *Broadway and Trinity Church.* Watercolor. The New York Public Library, Stokes Collection.

The artist who made this drawing used a light-colored wash first. The wash changed the surface color of the paper and produced the background value and secondary shapes (seen in the upper right, and along the left side of the composition). The preliminary drawings in the background were scrubbed with a towel so that only traces of the originals remain. Contrast this technique with the drawing in the upper right-hand corner. A broad-pointed implement, perhaps a stick, held straight up, produced the patterned line of the central figure. This was drawn over a dark watercolor shape, containing the line drawings.
Ben Shahn, *Prometheus*. Watercolor, 24″ × 23″. Philadelphia Museum of Art, Fleisher Art Memorial.

Drawing can perhaps be broken down into three categories. There are drawings comprised of lines only, achieved with line-producing implements; form drawings, where the emphasis is on the volume, or mass of the form; and color and value drawings. This watercolor drawing by Leonard Baskin belongs to the third category. The artist emphasized dry-brush drawing and demonstrates his mastery of the medium. Note especially the legs and head of the flea. Pen and ink lines were applied for contrast and details, and to separate form from value.
Leonard Baskin, *Flea*. Watercolor, brush, pen and ink, 22¼″ × 30″. The Museum of Modern Art, New York, gift of the artist.

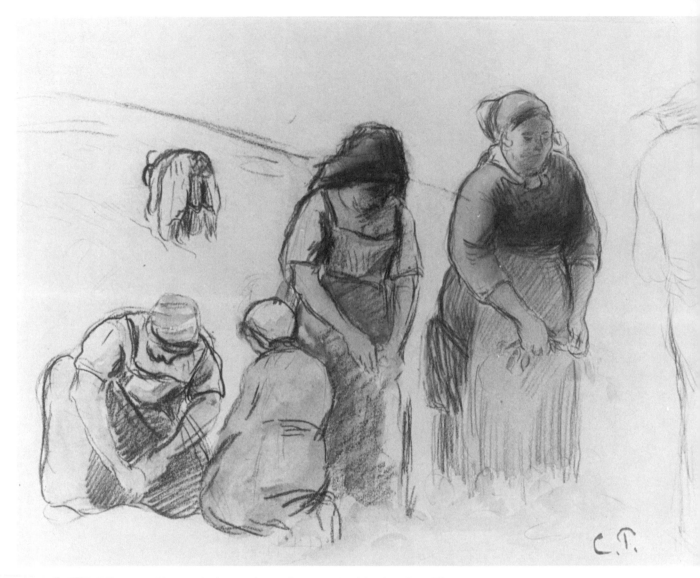

The versatility of watercolor and charcoal can be seen in this drawing. The figures in the lower left have watercolor washes contained inside charcoal lines, whereas the two central figures have watercolor applied over charcoal. Explore many combinations of dry and moist media with watercolor. Use a variety of brushes, papers and boards.

Camille Pissarro, *Pea Harvest* (recto), ca. 1880. Watercolor and charcoal, 9″ × 11″. The Armand Hammer Foundation, Los Angeles, California.

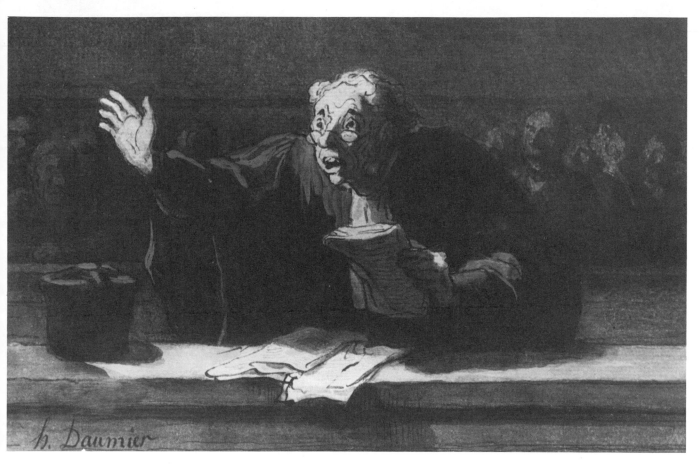

Honoré Daumier made a watercolor drawing using dark green, black and blue watercolor. The dark values effectively isolate the central figure from the background. Pen and ink lines delineate the hands, facial features, hair and paper documents. Light blue gouache was brushed on the robe to describe light falling on the form and to separate similar values. Try making a drawing with watercolor and charcoal. Add accents of white gouache, or brush in white acrylic pigment.

Honoré Daumier, *The Pleading Lawyer*, ca. 1843–46. Watercolor, ink and gouache, 6¼″ × 8½″. The Armand Hammer Foundation, The Armand Hammer Daumier Collection Los Angeles, California.

This self-portrait combines watercolor and pencil. Large areas of freely applied, flat washes divide and describe space and form. The face is an accurate representation and was done with a pencil held close to the point to gain control over the image. Traditional modeling and cross-hatching contrast with the yellow, green and blue watercolor washes. Make a drawing with emphasis on watercolor washes and use a contrasting medium such as pen and ink, crayon or charcoal. Emphasize contrast of value, line and texture.

Maryrose Mendoza, *Self-Portrait with Brush*, 1983. Watercolor and pencil, 22″ × 30″. Courtesy of the artist.

Anna Rodrigu[...]

14

COMBINED AND MIXED MEDIA

Traditionally, it seems reasonable to suggest that artists begin their drawing work with the purer media such as charcoal, chalk, conte, pencil and ink. As artists develop increased perception and experience, they often develop skills with the more complex drawing media and move to an interest in combinations of media.

No drawing student should be limited to a single medium. Nor should they have to master one medium before moving on to new media. There are as many uses of media as there are inventive artists. Ultimately, the way an artist uses media reflects the individual's uniqueness and personal expression. In previous chapters, you saw some ways in which artists chose to use various media.

Beginning artists often work with a chosen

medium for countless drawings, and for long periods of time. Their preferred medium may be easily accessible, easy to use, erasable or neat. Beginners may find it easy to understand why an artist exhausts a certain medium, or how and why it was used. It can be harder for beginners to understand why many artists have not limited their choices of media, but have chosen to use mixed and combined media.

Mixed and combined media result from the infinite combinations of implements, media, and techniques possible in an artwork. Mixed and combined media may enhance expression, yet they will not solve perceptual problems, nor guarantee a harmonious drawing. Skills and artistic sense can find rich challenges here.

Many ancient, modern and contemporary artists

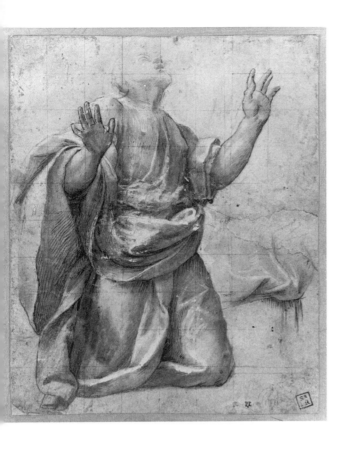

Not all artists have the ability or discipline to combine media freely and still have a unified drawing. Bernardino Gatti made this drawing as a study for a painting. He used black chalk to initiate the drawing, followed by brush and pen and ink to intensify the blacks. Body color in the form of opaque tempera and gray washes were used with yellow and pink pigment for accents. Try making a mixed media drawing by starting with charcoal. Spray those areas of charcoal that you wish to preserve. White acrylic or gouache can be dry-brushed on the drawing. For contrast and interest, pencil, conte or ink lines can be added.
Bernardino Gatti, *Study of an Apostle Kneeling.* Combined media, 15⅞″ × 8¾″. Ashmolean Museum, Oxford, England.

This drawing by Claes Oldenburg skillfully combines mechanical drawing with free-hand drawing. The artist transformed an everyday object into a monumental structure. Pencil lines define the form of the faucet, and crayon provides the necessary modeling to give the form a three-dimensional appearance. Wash over pencil and crayon describes the background shrubbery. Claes Oldenburg, *Proposal for Colossal Structure in the Form of a Sink Faucet for Lake Union, Seattle, Washington,* 1972. Crayon, pencil and watercolor, 28⅞″ × 22⅓″. Courtesy of the artist.

developed their drawings through improvisation, using appropriate media to reach their goals. As your imagination develops and you gain experience in drawing, encourage your freedom and inventiveness in the use and combinations of materials. Your drawings will take on fresh and original dimensions. Eventually, when you wish to create certain tones, textures, colors or linear effects in your drawings, you will see the importance of improvisation. This is especially true when desired implements and materials are not easy to get. Throughout history, the absence of materials has stimulated the invention of many devices and media. Study the examples of mixed and combined media in the previous chapters of this book. Look for interesting combinations of media. Notice how the artist solved the problem of using more than one medium to achieve a unified drawing.

In creating this cartoon-like drawing, the preliminary work was done with colored pencils. These were followed by crayons, markers, and ink. Opaque pigment was used for highlights, and plastic doll's eyes were used as collage material, giving the drawing an additional element of surprise.
J. Michael Walker, *J.J. Audubon, Bird Painter.*
Combined media. Courtesy of the artist.

It's hard to imagine this drawing without the white accents. They contrast with the gloomy, dismal mood created by the artist's use of black crayon, charcoal and ink. When you view this drawing with half-closed eyes, the white accents rhythmically move through the composition. They help establish space, light and mood. The light values are symbolic, suggesting a few bright spots in an otherwise hopeless situation.
George Bellows, *Dance in a Madhouse.* Black crayon, charcoal pen and ink, with touches of red crayon and Chinese white. The Art Institute of Chicago.

This drawing combines pencil and collage. A section of an image, perhaps a photograph, was used as the catalyst for the drawing. The collage was not an isolated compositional element. Instead it became an integrated part of the drawing when the artist drew on it with a soft pencil, producing value and line. Additional interest was achieved by the placement of the subject on the picture plane.

Jim Dine, *Four Chairs #12.* Collage and pencil, 18″ × 24″. Sonnabend Gallery, New York.

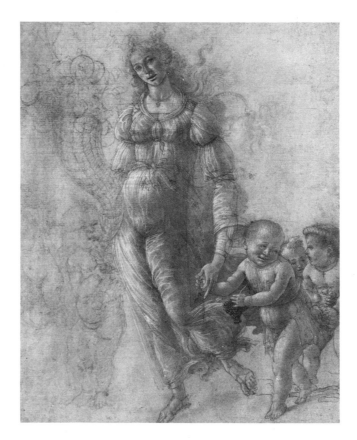

This drawing by Sandro Botticelli is perhaps one of the most widely-viewed drawings ever made. The artist used an extremely fine pen point to draw the very delicate lines of the figures, followed by black chalk and opaque pigment for highlights. On the hand made pink paper, the artist completed the drawing with silverpoint outlines. Try covering a piece of watercolor paper with thin layers of gesso or Chinese white. After it dries, make a drawing with a thin silver wire and combine the drawing with other media, perhaps acrylic and charcoal.

Sandro Botticelli, *L'Abbondanza.* Fine pen heightened with white over black chalk and silverpoint on pink paper, 12½″ × 9⅞″. The British Museum, London.

This drawing was begun with sanguine conte dust, applied with a piece of folded paper to research the form. A stiff bristle brush held close to the tip was used with short, scrubbing motions to apply yellow, red, blue and white acrylics. Yellow was used to describe near forms. Red and blue were used for mid-distant and distant forms. White was used for accents and highlights. Periodically, the artist stopped work with the acrylics to redraw the form with conte and charcoal sticks for value and line. On some areas the two dry media were blended using folded paper and finger tips, while other areas were preserved with acrylic spray. The process of alternating media can be repeated several times.
Wendy Shon, *Reclining Figure*. Acrylics, conte, charcoal, spray, 24″ × 36″. Courtesy of the artist.

On this drawing, American artist Richard Diebenkorn used crayon, gouache and watercolor. The placement of the figure on the picture plane divides the space in an interesting manner, and gives the spontaneous application of media an added dimension of excitement. Opaque gouache was used to redefine the form of the chair, to describe space and to create the flowered pattern of the dress. This is rendered in transparent watercolor. Try making a series of drawings using opaque and transparent media.
Richard Diebenkorn, *Seated Woman #44*. Watercolor, gouache, crayon, 30¼″ × 23½″. Student Association, State University of New York, Albany.

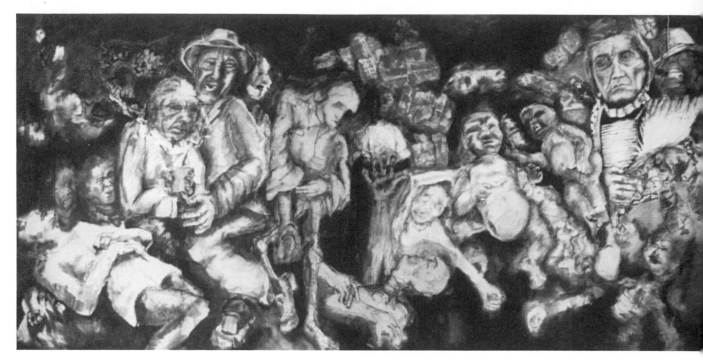

The artist who made this large mixed-media drawing
used a collage of photographs as a catalyst for the
work. The media included are charcoal, conte, wash,
pen and ink, acrylic pigments and areas of collage
comprised of newspaper want ads. To prevent the dry
media from smearing, and to allow the artist the
freedom to rework certain areas, an acrylic fixative was
sprayed on the surface. The surface is an upsom board,
available at building supply stores or lumber yards.
Tracy McClure, *Man's Inhumanity to Man.* **Combined
media, 4' × 8'. Courtesy of the artist.**

Gold watercolor was used to begin this drawing and to
describe the highly decorative border. Watercolor was
followed by oil pastels over graphite. The drawing was
then rubbed with a soft gum eraser and worked into
with oil pastels and graphite. The drawing is a study of
an Art Deco architectural detail.
Brad Davis, *Turk Burst,* 1973. Oil pastel, graphite and
gold watercolor on paper. Courtesy of the artist, collec-
tion Holly and Horace Solomon.

The definition of drawing has expanded to include works transferred to canvas, normally associated with painting. Pablo Picasso cut shapes from paper and adhered them to canvas, and drew over the shapes with charcoal, wax crayon and ink. It would not be difficult to alter a drawing using this technique. The paper shapes could be removed, new shapes glued over existing ones, or an opaque white pigment could be applied over unwanted areas. Try combining collage with a mixed-media drawing. Use photographs or colored papers and cut them into interesting shapes.

Pablo Picasso, *Guitar,* 1913. Cut and pasted paper, charcoal, wax crayon and ink over canvas, 26⅛″ × 19½″. The Museum of Modern Art, New York.

Anna Rodrigue

15

MONOTYPES

Monotype is a fascinating technique available to artists. It is highly popular in this century. The technique was invented in 17th-century Italy. A single image, a monoprint, is made from a drawing that is done on a metal, plastic or glass plate. The drawing is done with pigment, and then paper is put on the plate, pressed, and the image is transferred to the paper.

Artists enjoy this technique because it is a way of achieving unique surface and textural qualities in a work. Monoprints are unlike works attained by drawing directly on a surface. It is possible to make additional print impressions by reinforcing the ghost image of the remaining pigment on the plate. No two monotypes will be identical, even when made from the same plate.

Monotypes can be made with printing inks, oil

paints, water-based pigments, or acrylics. With each medium, it is necessary to understand the relative drying rates of pigments. These determine the amount of time allowed for work on the plate before making an impression. Oil paints allow considerable working time. Oil pigments can be thinned with turpentine and applied several ways including brushes to make tones and lines. Pigments that use water as a solvent should be monitored to prevent rapid drying. A few drops of glycerin added to water-soluble pigments will slow down the drying time. You can keep a spray container near-by and occasionally spray a light coating of water on the plate as you work. The consistency of the pigment is important, and only by several attempts can you determine which is best suited for your needs. Plan to practice a bit.

In monoprinting, many techniques are possible. You can draw directly on the plate. Adding pigment to the plate will result in a positive image. You can cover large areas or the entire plate with a thin coat of paint or ink, and draw in reverse by removing pigment to create light areas. To remove pigment, you might use a rag, paper towel, cotton swab, stick, cardboard scraps or even your fingers. Subtracting pigment from the plate results in a negative image.

When you feel satisfied with the drawing, place a dampened piece of paper on the face of the plate. Smooth and press down the paper. Use your hands or rub the back of the paper with a wooden spoon or paddle, or with an instrument for rubbing prints called a "baren." You can make or purchase a baren. Be sure that the paper cannot move while you are making the impression. When you have rubbed the entire sheet, remove it from the plate. Use a smooth, steady motion so that the paper cannot smear or double print. Monotypes permit further exploration by working and reworking selected areas of the print. Many artists draw on the completed monotype with other media. They are seldom satisfied with only the impression of the monotype, choosing instead to enrich the surface later.

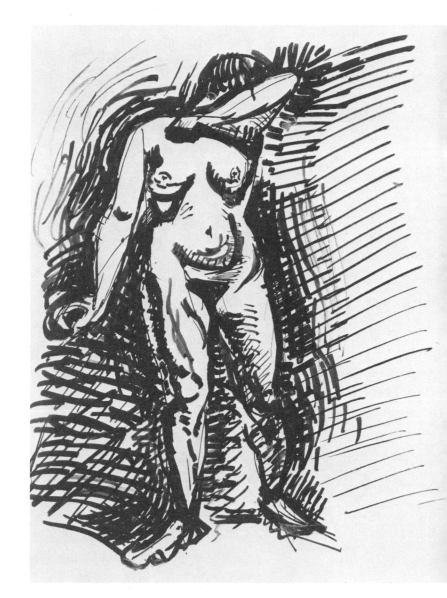

Monotypes can be made by coating the entire plate with a thin layer of pigment and then removing paint from selected areas. This produces line and value against a dark field. Paint removal can be done with sticks, rags or paper towels. When you draw directly on a plate, however, you can add as well as subtract pigment, producing a dark line against a light field. This monoprint by Henri Matisse was done using the latter technique. This contributes to the bold, direct, expressive image. After making a few monotypes, you will be able to compensate for the reversal of the image that results from printing the plate on paper. Henri Matisse, Standing Nude, Arms Folded, *1915. Monotype, printed in black, plate, 6^{15}⁄$_{16}$" × 4^{15}⁄$_{16}$". The Museum of Modern Art, New York, Frank Crowninshield Fund.*

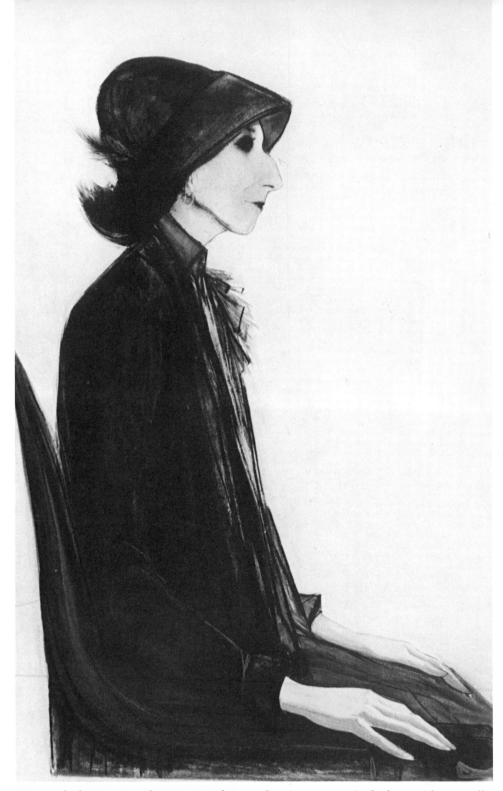

Master draftsman Joseph Mugnaini began drawing on a metal plate with a small piece of matboard and printing ink. As the drawing progressed, the artist used his fingers, cotton swabs, rags and a stick. A brayer was used to add pigment to the plate, resulting in the solid areas of color on the print. The addition of pigment produces lines, values, textures and patterns, while the subtraction of pigment results in negative areas of the drawing. After the impression was made, in this case on a press, the artist drew into areas of the print with a piece of matboard and oil paint.

Joseph Mugnaini, *Isak Dinesen*. Monotype, 24″ × 30″. Courtesy of the artist.

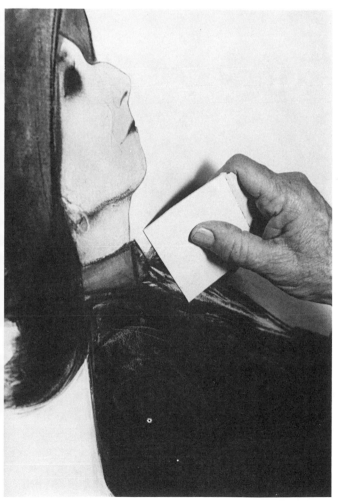

Frottage is a process not unlike many contemporary drawing techniques. It serves as a point of departure for this drawing. A Frottage is made by covering a textured surface with a piece of paper, and then rubbing the paper with a pencil or conte crayon. The texture under the paper determines the result. Often the texture is based on chance findings. This enables the artist to emphasize variations in media application and inadvertent results that can enrich the drawing further. Once the object or material has been removed from underneath the top sheet, the artist can use additional media, collage and color.
Robert Indiana, *The Great American Dream: New York,* 1962. Conte, 25″ × 19″. Courtesy of the artist. Photograph, Eric Pollitzer.

16

NON-TRADITIONAL MEDIA

Developments in history, philosophy, psychology and technology all contribute to the many images we see today. Like 20th-century painting, drawing has kept pace with new media, techniques, and philosophies. Artists who draw constantly, like painters, have broken through conventional restrictions to explore new directions, and use media in different ways to create varied effects and unique results. Increased exploration and invention yield rich and new directions in drawing.

In previous chapters, you studied drawings created by artists with varied abilities. Some used media simply and directly, and others amplified the media, using them to their fullest potential. Some artists altered media to suit personal goals, and still others used media in highly inventive ways. Regardless of the manner in which media are used, and regardless of the period, style, or technique, artists use the visual elements. Lines,

colors, values, shapes and textures must be considered in the creation of all drawings.

This chapter is about non-traditional drawing media and the ways artists use them. The examples shown here do not include mechanical, copy machine, xerography and computer art. Instead this chapter shows artwork made using only the materials and tools that are easy to incorporate into the drawing experience. Media described here are easily accessible or portable, inexpensive and not complicated to use, combine or store.

Non-traditional media include those that are not normally associated with drawing. With experimental media the exact outcome is not certain. This chapter covers special media or implements developed by artists. Implements may be made from plants, hairs, straw, sponges and rags, for example. Unusual media include iodine

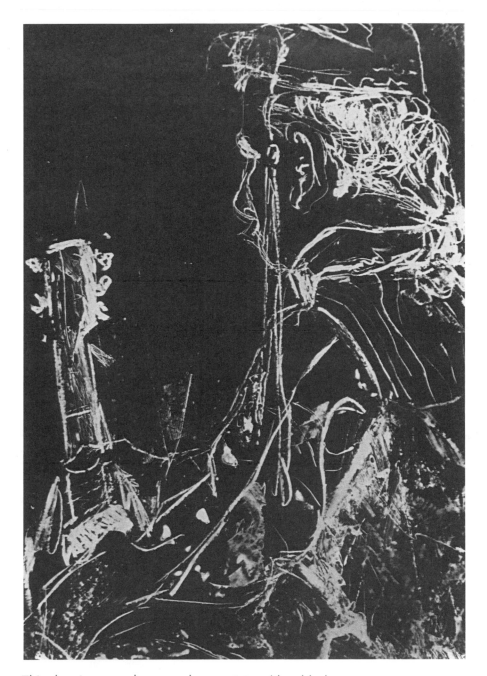

This drawing was done on clear acetate with a black grease pencil. Plastic wrap, drop-cloth material, clear floor covering or plexi-glass can be used as well. Crayons, oil pastels, liquid asphaltum and opaque medium used by photographers can be used as the drawing media. The acetate drawing then was printed on to photography paper. You can also use the drawing in front of a light source or window.
John Bordon, *Figure*, 1986. Acetate, grease pencil.

The work of American artist Ed Ruscha is a classic example of an artist who constantly searches for inventive image-making and the imaginative use of media. He employs unorthodox materials as a catalyst for his images. This drawing was done with a dye from blueberries and egg yolk. Even though the choice of media appears to be non-traditional, many ancient artists also used root, vegetable, fruit and other natural dyes and stains. Often these were held in suspension with egg yolks. Egg tempera paint is an example of this.
Ed Ruscha, *Baby Cakes*, 1974. Blueberry extract, egg yolk on moire. Collection Jared Sable Gallery, courtesy Leo Castelli.

Cordelia Gray, *Anguish* (after Rodin). Acetate drawing, 20″ × 24″. Courtesy of the artist.

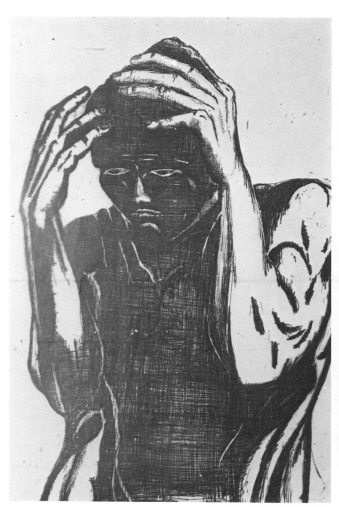

or Mercurochrome stains, shoe polish, food dyes, brewed coffee or tea, juices, crushed berries, pigments from soil, liquid graphite, machine oil, liquid asphaltum, orange shellac and lampblack, to name a few. You can experiment with a host of non-traditional drawing surfaces, as well, such as wood, plastics, glass, leather, fabrics and hand-made papers.

Remember that no medium, traditional or non-traditional, will compensate for poor perception or technical skills. No medium will determine when a drawing is unified, when emotional impact has been achieved, or when a medium has been used to its fullest potential. Only you can do that.

The endless combinations of media and surfaces make it virtually impossible to explore the complete spectrum. Yet non-traditional media are not entirely different from traditional drawing media. Both offer broad artistic challenges, fresh with each drawing you begin. Both should be experienced to enable you to achieve your greatest potential as a drawing artist.

These two drawings demonstrate the range of values and control or freedom possible using chemicals and photography paper. The developing solution makes dark values. The fixing solution halts the darkening process, preserving the white of the paper. Normally, during the photograph printing process, the two chemicals are not willfully contaminated by mixing. For this drawing technique, however, you can obtain unique results by applying one chemical on top of another, or varying the strength of the chemicals by diluting with water. This produces areas of rich oranges, browns, yellows and purples. A drawing can be further enriched with ink line or markers, or by applying high intensity dyes after the photography drawing has been completely washed and dried.

Alice Chung, *Mythological Beast.* Developer, hypo (fixer), 11″ × 14″.

Anne Shield, *Portrait.* Developer, fixer, ink and dyes on photography paper, 24″ × 30″.

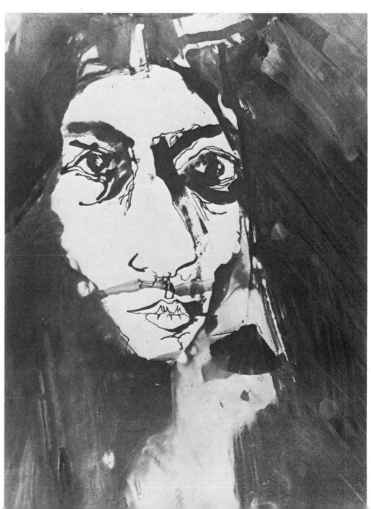

Acetate

Cover one side of a piece of acetate with black spray paint, or use an inexpensive latex paint applied with a roller. The acetate sheet should be approximately .007-010 mm thick, or about as thick as a desk blotter cover that can also be used. When the paint has dried completely, draw, scratch and scrape through the pigment layer down to the plastic sheet. Use a sharp implement such as a compass point, a sharpened nail taped to a stick, or an xacto knife. When completed,

your drawing will be composed of white lines against a dark field.

Unless specifically desired, the acetate master should be made opaque. There are techniques, however, that can be used on the acetate that will produce a broader rendition of the visual elements. Solvents can be applied to the paint layer, causing it to separate, producing a texture. The surface can be sanded with sandpaper to create values. Textured materials can be placed underneath the master, so that when the surface is sanded, an image of the underneath material remains. India ink, crayons, grease pencils, and acrylic pigments can be used to block out areas of the drawing. These can be removed later, for variations of the printed image.

When completed, the acetate drawing/etching, can be used as a light drawing, viewed with back lighting. The acetate master is effective, as well, for multiple impressions that can be reproduced on a variety of light-sensitive surfaces, such as photography paper, diazo paper, dichromate surfaces, and blueprint paper. A separate discussion of each technique follows.

To reproduce an acetate master on photography

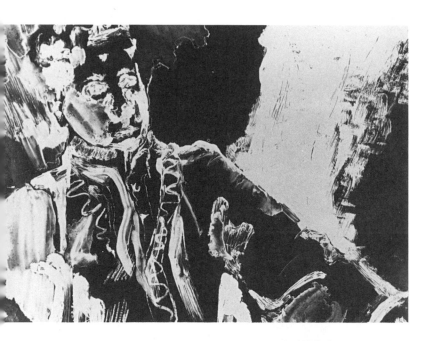

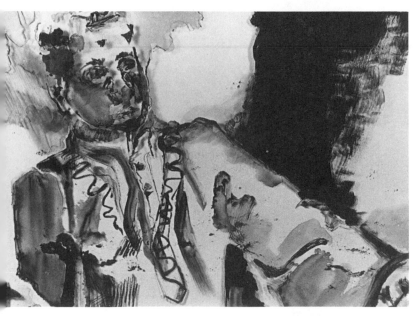

Michael Gordon, *Seated Figure*. (Top) Light drawing on acetate. (Bottom) Acetate drawing printed on light sensitive paper.

Rosa Floyes, *Head Study*. Acetate, black spray paint, 11″ × 14″.

paper, you will need a small darkened room with standard photography safelights. These prevent inadvertent exposure of the paper and provide enough light for you to work. You will also need a source for water, three photography trays or plastic pails or tubs, sponges, and the basic chemicals to develop and fix black-and-white photography paper. You will need a slide projector or a strong light source such as a desk lamp. To make a print, place the acetate master on the photography paper, and tape or pin the combination on a wall. Have the acetate master facing the light source, with the photography paper behind it. Expose the two for a few seconds to white light. After exposure, the photography paper must be processed under the safelight. Submerge the paper in trays of developer, water and fixer. If trays are not available, processing can be done with large sponges dipped into the chemicals. Keep the chemicals in plastic pails or tubs. Try not to mix sponges. Simply apply the developer to the surface of the photography paper with a sponge until the desired darkness is achieved and move on to the next processing step. Always follow instructions for mixing chemicals and storing and handling paper. Try using several different masters, double and triple exposures, moving the master during exposure, and drawing into a completed print with traditional media, especially high-intensity dyes.

Robert James, *Skull*, 1963. Photo drawing from acetate, 20″ × 24″.

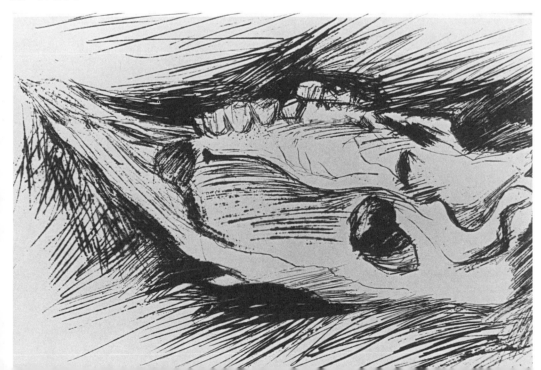

Potassium Dichromate Prints

Gum arabic and potassium dichromate can be purchased at science centers, or from chemical merchants. **Chromates are highly poisonous. Follow directions for mixing and using.** Both of these chemicals are common materials, not expensive, easy to mix and use, and can be adapted for drawing, especially when using an acetate master. Start by spraying a sheet of watercolor paper with liquid starch and allowing it to dry. Mix five parts of potassium dichromate crystals with one part water, until the crystals are dissolved, or until the solution is saturated. Store the mixture in a dark container. To make a print, prepare a working solution of one part gum arabic to two parts of the bichromate solution. Coat the paper evenly on the sprayed side with the chemical and allow it to dry. Protect the sheet from light during the drying. When this has been accomplished, place the acetate master on the coated side of the paper and expose it to sunlight, a sun lamp or a photoflood lamp. Experiment with exposure times with each light source and determine when the drawing is dark enough for you. Usually the drawing will be dark after a few minutes. When the image suits your needs, develop it immediately in warm water and allow it to dry. A sheet of glass or plastic will keep your master and sheet of paper flat during the exposure time. You can add watercolors when you coat the paper with the chemical, and the process can be repeated up to four times on a single sheet of paper.

Cathy Curl, *Figure,* 1984. Acetate drawing, dichromate print, 11″ × 11½″. Courtesy of the artist.

Blueprint drawings

Once you have completed an acetate master, it can be printed on blueprint paper. You will need fresh blueprint paper, purchased at duplicating or blueprint companies. You will also need one or two plastic trays and a fixing agent for the paper. The fixer is prepared by mixing one part of 3% peroxide to eight parts of water, or one half cup of peroxide in a gallon of water. Place the acetate drawing on the blue side of the paper and expose it to sunlight until the background of the paper turns slightly darker than the original color. The exposure time is determined by the brightness of the sunlight as you work. After exposure, the paper should be immersed in the fixer for a few seconds, or until the print becomes bright blue, leaving clear white or light blue images. Rinse the print in water, then blot dry.

Diazo paper

Diazo paper is also available at blueprint suppliers. It is inexpensive, and is easily adapted to drawing techniques. An acetate master is also the basis for this technique. As with photography paper, blueprint paper and dichromate surfaces, precautions should be taken to avoid inadvertent exposure to light. The surface of diazo paper contains azo dye and other light-sensitive chemicals. Exposure to sunlight causes the dyes on the paper to fade except where no light gets to the paper. For your work this should be the areas that are opaque on an acetate master. Exposure is usually completed when the yellow color of the paper fades to white.

Diazo paper is developed and fixed by the fumes of ammonia. Use a glass-covered or plastic tray or tub to hold the ammonia. A cup of household ammonia is usually sufficient for normal sized photography trays. When larger trays are used, provide enough ammonia to cover the bottom of the tray. **Follow safety precautions when handling ammonia.**

A wire screen with a ¼-inch mesh should be fitted to the tray. This will act as a platform for the paper to rest on while chemical processing takes place. The screen should rest below the rim of the tray, and just above the ammonia. It should also allow a glass cover to fit on the tray, preventing the ammonia fumes from escaping into the work area.

...board is another technique available to artists. It
...omplicated, and the results are unique. A piece
...tration board is covered with a smooth, thin
...of gesso, allowed to dry and then covered with
...roof ink. When the ink has dried, scratch
through the ink coating to expose the white gesso
layer. Use a sharp stylus, needle or sharpened nail
that has been taped to a small stick or pencil. The
result is a precise drawing which resembles a white
line engraving.

Christa Schmidt, *Figures*. Scratch board, 8″ × 10″.
Courtesy of the artist.

Jessica Goddard, *Sandals*. Scratchboard, 9″ × 11″.
Courtesy of the artist.

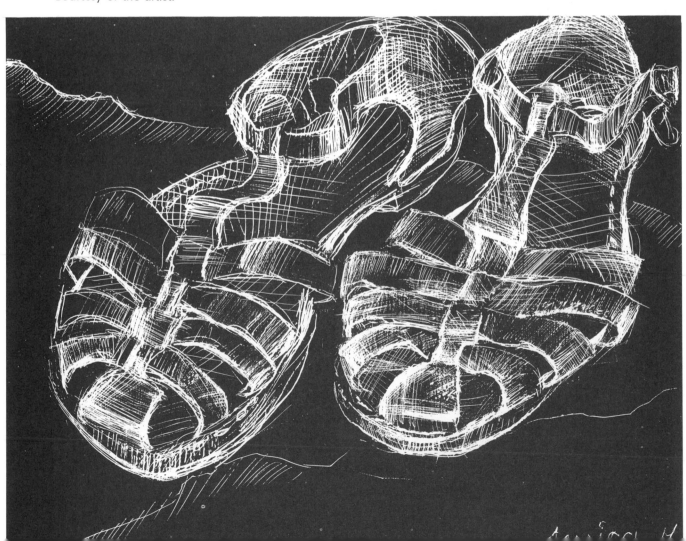

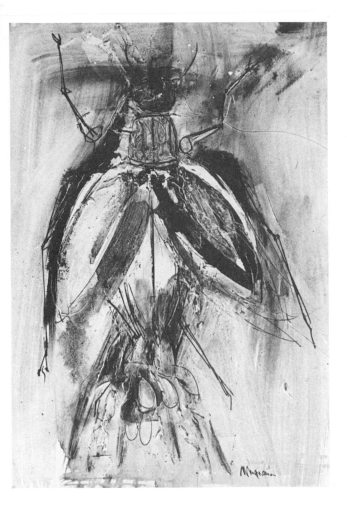

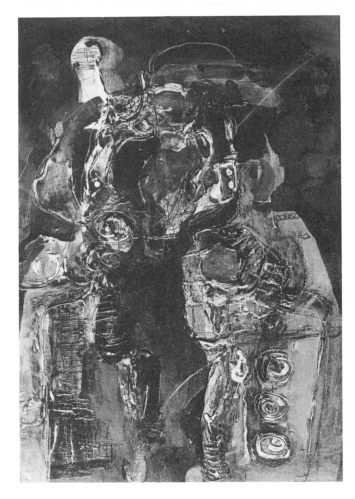

A thick, paste-like gesso, up to ¼-inch thick, was used to begin these drawings. Gesso is made of gypsum or chalk mixed with water or glue. A putty knife that can be purchased at a hardware store was used to apply the gesso to an illustration board with emphasis on drawing shapes, patterns and textures. The preliminary gesso drawing was allowed to dry, followed by any of several combinations of dry and liquid media, including charcoal, conte, chalk, ink, gouache, watercolor, acrylics and oils. The white gesso can be re-established by using sandpaper to sand areas of the drawing in need of change. Lines can also be drawn by cutting into the dry gesso with a blade or stylus. Try making a drawing with gesso and combined media, based on an adjective such as crashing, floating, pushing, pulling, clustering, falling, and so on.
Joseph Mugnaini, *Fly*. 20" × 24".
Joseph Gatto, *Genesis*. Combined media on board, 20" × 24"

Transfers are made by using a solvent for printer's ink, of which there are many, in both liquid and gel form. **All are hazardous. Follow safety precautions strictly.** Included are turpentine, lighter fluids, mineral spirits, acetone, rubber cement thinner and silkscreen extender base. The latter is in gel form and is easier to use. To make a transfer using extender base, tape a magazine reproduction to a piece of smooth drawing paper, image side down, and coat the back side of the reproduction with the gel, allowing it to soak through the paper for a few minutes. Rub the gel with a paper towel, using circular motions, or until you can see the image through the magazine paper. With a soft pencil, scribble on the back side of the image, transferring it to the drawing surface. If a liquid solvent is used instead, moisten the drawing surface first, and periodically apply the solvent on the back of the reproduction until the transfer is completed. You can check the process by looking underneath a corner of the reproduction. Masks, made from newspaper will keep your surface clean.

Grace Robertson, *Untitled*. Transfer, pencil, marker, oil pastel on paper, 6″ × 9″. Courtesy of the artist.

Image transfer is a relatively new drawing technique that was introduced as an art form several years ago. The process requires taking reproductions from magazines and separating the thin layers of printer's ink from the slick, clay-coated paper and transferring the image to a drawing surface. The transferred image can then be further enriched with additional drawing media. American artist Robert Rauschenberg made thirty-four images that were used as illustrations for the literary work, Dante's Inferno.

Robert Rauschenberg, Canto XXXI, Illustration for Dante's *Inferno, The Central Pit of Malebolge, The Giants,* 1959–60. Red and graphite pencils, gouache, transfer, 14½" × 11½". The Museum of Modern Art, New York, given anonymously.

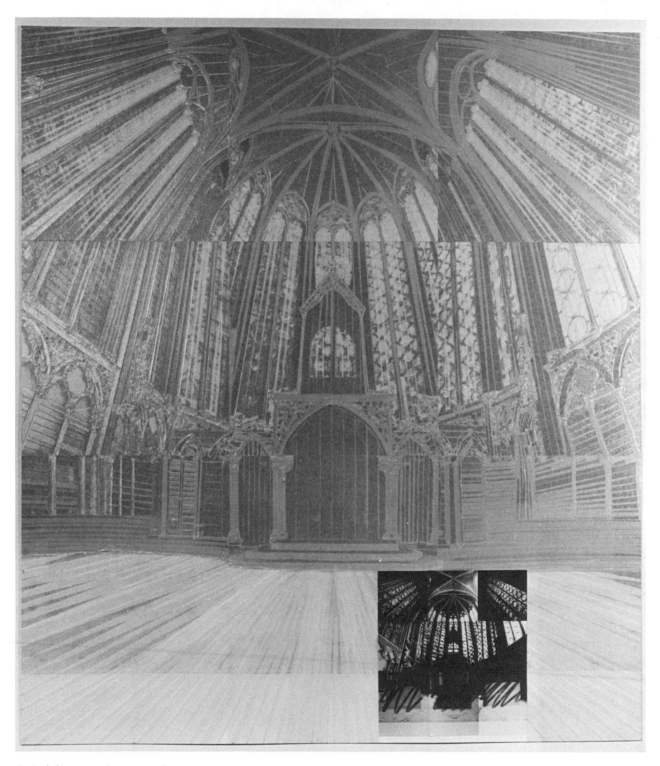

Artist/photographer Patrick Nagatani used common masking tape as a non-traditional drawing medium. The artist used different values of masking tape to create line, value and texture by tearing, cutting, and overlaying the shapes and strips of tape to enrich the underneath photographic image.

Patrick Nagatani, *Colorful Cathedral.* Photographic image and masking tape. Courtesy of the artist.

Artist Barry Fahr has developed an interesting drawing technique. A black-and-white negative was projected onto photography mural paper. The mural paper was printed and processed, and then was stretched on stretcher bars of the kind used behind canvas paintings. The image was then drawn into with colored pencils, brush and airbrush. The artist felt free to alter the image to depict the way he felt when the photograph was taken. The drawing media and techniques were used to crisp up edges, define any blurred images, and to produce surface textures. This unfinished drawing demonstrates those areas that have been manipulated with drawing media and the section of the photograph that has not been altered.

Barry Fahr, *Tree on 20th Street*. Photography, pencil, ink and airbrush, 18″ × 24″. Courtesy of the artist.

American artist Loretta Dunkelman has developed an interesting drawing technique. Colored chalks with a combination of oil-wax binder were used to build up several thin layers, permitting light to pass through and making the underneath drawing visible. White or a light-colored chalk was used to unify all the different colored chalks. The medium was allowed to dry, or was heated with a lamp to fuse the pigment layers. When this was accomplished, the surface was buffed lightly with a soft tissue, achieving an appearance of polished marble. Study the work of ancient Greek encaustic painters.
Loretta Dunkelman, *Ice Three*. Oil-wax, chalk (Caran d'ache) on paper, 42″ × 30″. Courtesy of the artist.

143

MEDIA COMBINATIONS

The following lists suggest additional combinations that you can try, using drawing media. These lists have been organized to parallel your interests, skills and confidence levels. The media presented here are in the same sequence as the chapters, in gradations from beginning through intermediate to advanced skill levels with drawing media.

Chapter 3: Charcoal

Charcoal over colored papers.
Charcoal on rough paper or cardboard.
Charcoal and colored chalk on colored papers.
Charcoal over graphite.
Charcoal, pencil, turpentine and red conte.
Charcoal over ball-point pen or markers.
Charcoal and dry-brushed acrylic pigment.
Charcoal and brown crayon heightened with white acrylic.
Charcoal, gesso, and acrylic spray.
Charcoal with high intensity dyes.
Charcoal with watercolor washes.
Charcoal and brown wash heightened with white chalk on blue paper.
Charcoal and ink washes.

Chapter 4: Chalk and Pastel

Black and red chalk with brown washes.
Black chalk and red crayons.
Black chalk and charcoal heightened with white acrylic.
Black chalk with watercolor and gouache.
Red chalk on gray paper.
Chalk and watercolor.
Black chalk, pen and brown wash heightened with white chalk.
Black chalk and pen and ink.
Black chalk on brown paper.
Gray chalk on light brown paper.
Black chalk on colored paper with white accents.
Red chalk with pen and ink.
Black and red chalk on white paper.

Black chalk heightened with white acrylic on gray paper.
Pen and wash on white paper over chalk.
Black and red chalk with oil pastels.
Chalk and conte.
Chalk and pencil.
Chalk and ball-point pen.
Pastel over pencil.
Pastel over ink.
Pastel, pencil or pen with touches of gouache.
Pastel over graphite.
Pastel, turpentine and soft pencil.
Pastel, charcoal and chalk.
Pastel and watercolor.
Pastel, chalk and oil pastel.
Pastel, clear acrylic spray and soft graphite.
Pastel, conte and ink.
Pastel, acrylic spray and acrylic pigments.

Chapter 5: Graphite

Graphite with charcoal overlays.
Graphite and soft pencil.
Graphite, pencil and turpentine.
Graphite, turpentine and pastel.
Graphite, charcoal and white acrylic.
Graphite and ball-point pen.
Graphite, turpentine, oil pastel and crayons.
Graphite and oil washes.
Graphite, powdered graphite, liquid graphite and soft pencil.
Graphite and watercolor or wash.
Graphite, oil washes and soft pencil.

Chapter 6: Conte

Conte and brown wash with touches of red crayon.
Black conte on blue-gray paper.
Pen and brown wash over reddish conte.
Sanguine conte with traces of charcoal.
Pencil, black conte and white chalk on light brown paper.

Black and reddish conte with light gray washes on gray paper.
Red and black conte with pen and ink.
Conte and charcoal rubbed and lightly washed with watercolor or ink wash.
Conte and charcoal with red crayon.
Conte and graphite.
Conte and pen and ink.
Gray conte on brown paper.

Chapter 7: Waxy Media

Red crayon on white paper.
Black, red, green and brown crayon on white paper.
Black crayon with highlights in red and green pastel on gray paper.
Black and red crayon on gray-brown paper.
Black crayon on yellow tracing paper.
Brown crayon heightened with white.
Black crayon, pen and ink on buff paper.
Black crayon, black, blue, and yellow wash on cream-colored paper.
Black crayon with a watercolor wash, heightened with white on brown paper.
Black crayon accented with pen and brown ink on white paper.
Yellow or white crayon with ink wash.
Black crayon and brown wash with blue watercolor.
Crayon applied layer upon layer and glazed by rubbing with fabric.
Crayon and watercolor wash.
Wax and turpentine with thinned oil pigments.
Crayon scratched (sgraffito) and drawn into with ink.
Wax worked over with turpentine and bristle brushes, then reworked with turpentine.
Crayon dipped in turpentine and drawn directly onto paper.
Crayon over turpentine.
Crayon and oil pastels.
Crayon and India ink.
Crayon over pencil, allowing the pencil to show through.
Crayon over high-intensity dyes.
Paraffin wax or dinner candles to initiate the surface, with dark wash and sgraffito.

Oil pastels, paraffin wax and watercolor or ink washes.
Oil pastels and crayons.
Oil pastels over graphite.

Chapter 8: Pencil

Pencil on cardboard with conte and white acrylic.
Pencil, charcoal, watercolor and gouache.
Pencil on white paper with touches of white acrylic.
Pencil accented with crayon, heightened with white chalk on colored paper.
Pencil over orange crayon.
Pencil, black crayon and white chalk on brown paper.
Pencil, brown, yellow and green washes on white paper.
Pencil, pen and ink on white paper.
Pencil over watercolor.
Pencil over turpentine and crayon.
Pencil, watercolor and gouache.
Pencil with brown wash.
Pencil, turpentine and conte crayon.
Pencil with high intensity dyes, gone over with charcoal when dry.

Chapter 9: Self-Contained Pens

Ball-point and red, black, blue chalk or pastel.
Ball-point, graphite, crayon.
Ball-point, pencil, gouache.
Ball-point and crayon.
Ball-point and markers.
Ball-point and brown ink.
Ball-point and watercolor.
Ball-point with touches of oil washes, and crayon or grease pencil.
Markers, ink, ball-point pen.
Markers and ball-point pen.
Markers and India ink.
Markers with wash and acrylics.
Markers over colored papers.
Markers with high intensity dyes.
Markers re-drawn over a monoprint.

Chapter 10: Ink

Ink over tracing paper.
White or black ink on colored papers.
Ink on textured papers.
Ink over charcoal.
Ink over pastels.
Ink and chalk over colored papers.
Brown ink over black chalk.
Ink over graphite.
Brown ink over chalk on light red paper.
Ink over crayon or chalk.
Black or brown ink over red crayon.
Ink with gouache.
Ink and tempera on parchment.
Black or brown ink heightened with white on
 red paper.
Black ink and watercolor over black chalk.
Ink over watercolor.
Ink over dyes.
Ink, tempera and dyes on parchment paper.
Ink with markers.
Ink, wash, pastels.
Ink, collage, pen and ink.

Chapter 11: Washes

Brown washes with touches of sanguine conte.
Wash, black chalk, ink.
Brown wash and ink over graphite.
Gray wash and brown ink over charcoal.
Brown and yellow wash over pencil.
Brown wash and pen over red chalk with traces of
 watercolor.
Blue and brown wash over black chalk.
Gray wash over red crayon with pen and ink.
Brown wash over black crayon.
Green, yellow and red wash over pencil.
Brown and blue wash over pen and crayon.
Wash over pen and pencil.
White wash over pencil and lithographic crayon.
Pen and ink washed with brown wash over
 pencil.
Brown wash with touches of red, blue and white
 acrylic and red crayon accents.
Sepia wash on white paper over pen and ink.
Blue wash over red ink.

Brown wash over brown ink.
Gray and brown wash over pen and ink.
Gray wash over pen on brown paper.
Brown wash and ink with blue gouache.
Pen and ink washed with blue watercolor.
Charcoal wash over pen and ink.

Chapter 12: Gouache and Oil Pigments

Gouache and watercolor.
Gouache, watercolor, pencil.
Gouache, wash, brush and ink.
Gouache, graphite, brush and ink.
Gouache, crayon, collage.
Gouache, watercolor, acrylics.
Gouache, crayon, pencil.
Gouache, pastels, acrylics.
Gouache, oil pastels, watercolor, charcoal.
Gouache, pencil, pasted paper on cardboard.
Gouache, charcoal, pastel, ink.
Gouache, watercolor, pastel, ink on cardboard.
Gouache, charcoal, watercolor.
Red gouache, ink, pastel, watercolor.
Gouache and colored chalk.
Gouache on brown paper.
Dry-brushed oils and charcoal, conte, crayons,
 chalk, or graphite.
Dry-brushed oils, oil washes, charcoal.
Dry-brushed oils over pastels that have been
 sprayed with acrylic fixative.
Dry-brushed oils and oil-based markers.
Dry-brushed oils and ink.
Dry-brushed oil, oil washes and charcoal with
 accents of white chalk.
Oil washes with pencil or graphite.
Oils over dry gesso, with charcoal, conte, and pen
 and ink.

Chapter 13: Watercolor

Watercolor with chalk.
Watercolor with pastel.
Watercolor with conte.
Watercolor and graphite.
Watercolor and colored pencils.

Watercolor, wash, colored pencils.
Watercolor, gouache, pencil.
Watercolor, tempera, pencil.
Watercolor and ball-point pen.
White watercolor and charcoal.
Watercolor and watercolor dyes.
Watercolor, dyes, charcoal.

Chapter 14: Combined and Mixed Media

Charcoal and white watercolor or acrylics.
Pastel and acrylic.
Pastel, gouache, pen and ink.
Graphite, pencil, pastel.
Graphite, wax and pigment.
Pencil, crayon, gouache.
Pencil and collage.
Pencil and touche.
Crayon, watercolor, pencil.
Crayon, charcoal, pencil, watercolor, brush
 and ink.
Mixed media, collage.
Mixed media, ink, photographs.
Wash, pen, brush and ink, gouache.
Tempera, watercolor, pencil.
Oil and wax.
Oil, wax, chalk.
Oil pastel and graphite.
Oil and crayon.
Oil, graphite, acrylic.
Watercolor, gouache, pencil.
Watercolor, pencil, pastel.
Watercolor, crayon, pencil, pen and ink.
Soot and chalk on linen.

Chapter 15: Monoprints

After making a print, try making a second print from the first print. Make certain the first print is still wet and that the pigment has not dried out too much.

After making a first generation print, carefully peel the paper away from the printing surface. Rework the plate by directly painting on the sur-face. Make a second generation print by carefully moving the paper back over the plate.

Cover the plate with dark pigment and draw into the surface to create a negative image. Print and allow to dry. Draw into the printed surface with high intensity dyes, oil pastels or acrylic pigments.

Make a print from a plate in the usual manner. When the print has dried, place the print face down on a soft surface; draw over the ghost image on the back of the print with an embossing tool to create a relief image on the face of the print.

Make a print in the usual manner. Apply pigment onto thin paper surfaces and place on the face of the print. Print under pressure to transfer pigmented surfaces to the surface of the print.

Make a print in the usual manner on selected areas of the print, reestablish the white of the surface with collage material. Alter the image by drawing on the collage areas.

Chapter 16: Non-Traditional Media

Make a drawing on large sheets of clear acetate or plastic wrap, using a grease pencil, oil pastels or lithograph crayon. Lay the clear plastic over one of the following and print the results of your experiments. Use construction paper left in the sunlight to fade, or use blueprint paper, diazo paper, or potassium dichromate surfaces.

Make a drawing on heavy white paper or tag board. Use a pen, stick or brush dipped in gum arabic. A drop of ink in the gum arabic will make the drawing more visible. Allow the drawing to dry slowly. Drying is indicated by surface cracks. Coat the drawing with a thin wash of oil pigment thinned with turpentine. This should dry rapidly because of evaporation. Wash out the gum arabic with water, leaving a light line against a dark field.

Make a drawing on a sheet of glass using a grease pencil, lithograph crayon or oil pastels. When completed, lay a piece of paper over the drawing and lift the image from the glass by dampening the back side of the paper with turpentine. Apply the turpentine sparingly with a rag or towel.

GLOSSARY

Abstract Originating with a recognizable form, but simplified or distorted some way. Often the subject is unrecognizable in the finished artwork. See also Nonobjective.

Achromatic Having no color; a neutral such as black, white or gray.

Acrylic A synthetic paint based on acrylic polymer resin.

Aerial perspective (atmospheric perspective) The effect of atmosphere between the object and the viewer; the simulation of depth in two-dimensional art by the portrayal of this effect.

Anatomy The structure of the human body, principally the bones and muscles.

Binder A substance in paints that causes the pigment to hold together and adhere to a surface.

Bistre A brown pigment made from boiled soot, which was in use in the 17th-century, used primarily with pen and brush.

Bleed To allow a wash or other thin medium to run into and combine with another area of color. Calligraphy The art of beautiful writing.

Brush drawing Drawing created using a finely pointed brush; giving the effect of great spontaneity. This technique is particularly associated with calligraphy and Oriental art.

Cartoon A drawing made to scale on paper used in transferring designs as a basis for painting, tapestry, etc.; in the more popular meaning, a humorous drawing.

Chiaroscuro The use of dark and light values to imitate the effects of light and shadow found in nature.

Collage Primarily a two-dimensional surface to which bits of paper, cloth, or other materials are glued; first introduced by Pablo Picasso.

Composition The organization of the visual elements on a two-dimensional surface.

Conte A brand of chalk, stick or crayon available in sanguine (red), sepia, and soft, medium and hard grades of black and white.

Contour In two-dimensional art, a line that describes the edge of one or more forms.

Cross hatching Using patterns of parallel and criss-crossing lines to create tones on a drawing.

Cubism A style of art developed by Pablo Picasso and Georges Braque, characterized by several views of the same object and flat pictorial space.

Depth The degree of recession depicted in a two-dimensional work.

Draughtsman A person who specializes in drawing.

Dry-brush A technique used with watercolor, acrylic, oil and ink in which a dry brush is used to apply uneven areas of color on a surface.

Earth colors Pigments which exist naturally in the earth.

Flat Two-dimensional.

Foreshortening The application of the principles of perspective to a drawn or painted figure.

Frottage Taking an impression from a raised or textured surface by covering it with a sheet of paper and rubbing it with a soft medium such as conte or charcoal.

Gesso A ground made of gypsum or chalk mixed with water or glue.

Gouache Watercolor made opaque by the addition of white pigment.

Hatching The use of parallel lines to produce tone. Tones are made by varying the density of the lines.

Horizon line A perspective line used to describe the horizon at the artist's eye level.

Illustration A drawing, painting or print that accompanies a written text.

Imagery The art of making images or pictures, as in drawing or painting.

Linear perspective A system for depicting three-dimensional depth on a two-dimensional surface.

Mass A broad cohesive area in a work of art that forms a significant element in the composition.

Medium The material used to create artwork.

Modeling The depiction of light and shade to give the illusion of three-dimensional volume.

Monotype (monoprint) A single print made from a design which has been drawn or painted on a glass, metal or plastic plate.

Nonobjective Design that is entirely independent of the natural world; non-representational.

Outline A sketch or drawing which shows only the contour line without modeling.

Pastel A stick similar to chalk or crayon, comprised of powdered pigment and a gum binder.

Perspective A linear system by which an illusion of depth is achieved on a two-dimensional surface.

Pigment The coloring matter in paint.

Print An impression made usually on paper, from a master plate, stone or block.

Shape The external appearance of an object. The term is often used synonymously with form. Shapes are two dimensional, however, and forms are three dimensional.

Sketch A preliminary drawing or painting.

Support The two-dimensional surface on which a drawing or painting is made.

Tempera A paint made of powdered pigments mixed with a binder.

Tone The range of light and dark.

Turpentine A rapidly drying liquid, distilled from pine resin. **Follow safety precautions.**

Value The lightness or darkness of a color.

Wash Diluted watercolor or ink, spread over the surface of paper.

Watercolor A painting and drawing medium in which the binder is gum arabic.

Ando Hiroshige, *Awabi, Snipefish and Peach blossoms,* 1832. Woodblock, 10¼" × 14⅞". Collection Joseph Gatto.

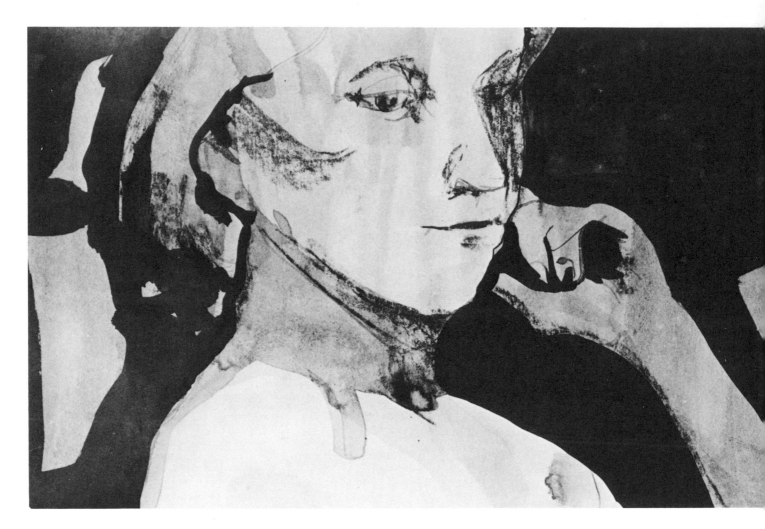

Caroline Cavella, *Portrait*. Ink, wash, traces of charcoal,
8″ × 13″. Courtesy of the artist.

BIBLIOGRAPHY

Brommer, Gerald F., *Drawing: Ideas, Materials and Techniques.* Worcester, Massachusetts: Davis Publications, Inc., 1972.

Chaet, Bernard, *The Art of Drawing.* New York: Holt, Rinehart and Winston, Inc., 1970.

De Tolnay, Charles, *History and Technique of Old Master Drawings.* New York: H. Bitner & Co., 1943.

Drawings of the Masters (twelve volumes by various authors). New York: Shorewood Publishers, Inc., 1963.

Koehler-Howell, Nancy, *Photo Art Processes.* Worcester, Massachusetts: Davis Publications, Inc., 1980.

Mayer, Ralph, *The Artists Handbook of Materials and Techniques.* New York: The Viking Press, Inc., 1957.

Mendelowitz, Daniel M., *Drawing.* New York: Holt, Rinehart and Winston, Inc., 1967.

Mongan, Agnes and Sachs, Paul, *Drawings in the Fogg Museum of Art* (2 vols.). Cambridge, Massachusetts: Harvard University Press, 1946.

Mugnaini, Joseph, *The Hidden Elements of Drawing.* New York: Van Nostrand Reinhold, Co., 1974.

Porter, Albert W., *The Art of Sketching.* Worcester, Massachusetts: Davis Publications, Inc., 1977.

Sachs, Paul J., *Modern Prints and Drawings.* New York: Alfred A. Knopf, Inc., 1954.

Waltrous, James, *The Craft of Old Master Drawings.* Madison, Wisconsin: University of Wisconsin Press, 1957.

ACKNOWLEDGMENTS

I would like to acknowledge the numerous individuals, galleries and museums for all their assistance and for providing the many images that made this book possible.

My sincere appreciation goes to the many artists, ancient, modern and contemporary, who made the drawings we respond to. They help to create in us the need for enlightenment through knowledge and understanding. These artists provide the inspiration to begin or continue drawing. Thus they maintain a centuries-old tradition of creative works with a truly unique form of visual communication.

I would also like to thank the many fine drawing teachers, students, and artists who made drawing exciting for me. My thanks go to everyone at Davis Publications for the opportunity to publish this collection of ideas about drawing. Finally, my appreciation goes to my wife Isolde and my children Nicole, Michael and Mariann for their patience and understanding.

INDEX

Diane Knopf, *The First Men in Space. Charcoal,*
22" × 34".